Mum's not the word

Childless
Childfree

DENISE FELKIN

EARTHWORLD
EXPANDING HORIZONS

EARTHWORLD
EXPANDING HORIZONS

EARTHWORLD is a brand new imprint in the house of Veloce Publishing, showcasing innovative and thought-provoking books that are informative and entertaining. Produced to the same high quality of content and presentation as our existing books, EARTHWORLD is set to push the boundaries, and expand horizons.

Also from Earthworld:
Discovering Engineering
Visit the sites of engineering feats that changed the world

Mr Trump goes to Washington
Political satire in 3D graphic novel form

Dairy Cows & Duck Races
Tales of a young farmer

Small-wheeled pedal machines – a better way of cycling
Discover the advantages of small-wheeled bicycles and trikes

Coming soon:
Peugeot Cycles
A celebration of the Peugeot brand during the golden years of cycling

The Book of the Leica R-series Cameras
The definitive history of Leica's SLRs

🐦 @mntwb @MumsNotTheWord_TheBook f @mntwb

www.veloce.co.uk

VELOCE PUBLISHING
THE PUBLISHER OF FINE AUTOMOTIVE BOOKS

Hubble & Hattie

Hubble & Hattie

First published in June 2019 by Veloce Publishing Limited, Veloce House, Parkway Farm Business Park, Middle Farm Way, Poundbury, Dorchester, Dorset, DT1 3AR, England. Tel 01305 260068/fax 01305 250479/e-mail info@veloce.co.uk / web www.veloce.co.uk or www.velocebooks.com. ISBN: 978-1-787113-70-1 UPC: 6-36847-01370-7 © Denise Felkin & Veloce Publishing Ltd 2019. All rights reserved. With the exception of quoting brief passages for the purpose of review, no part of this publication may be recorded, reproduced or transmitted by any means, including photocopying, without the written permission of Veloce Publishing Ltd. Throughout this book logos, model names and designations, etc, have been used for the purposes of identification, illustration and decoration. Such names are the property of the trademark holder as this is not an official publication. Readers with ideas for books about animals, or animal-related topics, are invited to write to the editorial director of Veloce Publishing at the above address. British Library Cataloguing in Publication Data – A catalogue record for this book is available from the British Library. Typesetting, design and page make-up all by Veloce Publishing Ltd on Apple Mac. Printed and bound in India by Parksons Graphics

Mum's not the word

Childless Childfree

DENISE FELKIN

Testimonials

This important and poignant book of photo essays by Denise Felkin brings some much-needed humanity to bear on the harsh judgements that our pronatalist society holds about women who don't have children. Each naked portrait is tender, vulnerable and raw, and the accompanying participant commentary is by turn shocking, illuminating, refreshing and heartbreaking. These women are literally laid bare, and this somehow gives them a greater right for their truths to be heard.

 Whether the women are childless due to infant loss, through motherhood ambivalence leading to a happy (or regretful) life without children, failed infertility treatments, clear-sighted self-awareness, unchosen singleness or other complex factors, they lie here and challenge us to appreciate for a moment what life might be like in their skin. Often those who've chosen non-motherhood – the childfree – are placed in one box, and those for whom this wasn't what they'd hoped (the childless) in another; yet this courageous and sympathetic book lays them side-by-side, and in doing so, reveals the lived complexity and ambiguity of being a non-mother in our motherhood-obsessed world.

JODY DAY, AUTHOR OF *LIVING THE LIFE UNEXPECTED: 12 WEEKS TO YOUR PLAN B FOR A MEANINGFUL AND FULFILLING FUTURE WITHOUT CHILDREN*, AND FOUNDER OF GATEWAY WOMEN (WWW.GATEWAY-WOMEN.COM)

As a filmmaker on the same subject, what I enjoy most about Denise's book is the vulnerability of the images. The raw honesty of women owning up at times to their struggles as well as their dreams, and the opportunities afforded to them by not having kids, is powerful. I have found in my work, and now in Denise's, that people are incredibly moved by the visual. Bravo, Denise: you have produced a body of work that will support many women.

MAXINE TRUMP, DIRECTOR, TO KID OR NOT TO KID, THE MOVIE

As a childfree-by-choice woman I think the book is an excellent way to share the stories and raise awareness of women who choose to be childfree or are childfree by circumstance. Society places a lot of expectation on women to have children, and you can feel as though you are the only woman who

doesn't want them. I think this book is necessary for women to hear the stories of those who are childless/childfree, and equally important for men to do so, too.

I love Denise's choice to have the women in a foetal position, too.

<div align="right">CALEY POWELL – PRODUCER, LIGHTS DOWN PRODUCTIONS</div>

Denise Felkin's *Mum's not the word* is an engaging and thought-provoking body of work. The artist clearly demonstrates how photography can be used to create debate, and the World Photography Organisation is proud to have recognised Felkin at the 2016 Sony World Photography Awards.

<div align="right">SCOTT GRAY, CEO, WORLD PHOTOGRAPHY ORGANISATION</div>

Denise Felkin is a wonderful photographer and documentary artist.

It's not easy to utilise conceptual photography effectively for any subject, let alone to try and communicate the thoughts and feelings of women without children, and the negativity they face in today's society. But Denise Felkin has done this beautifully with this remarkable series of photographs and words.

I am truly moved by this work, and thankful to Denise and the women in this book. I learned a lot.

<div align="right">TONY BELL, *THE OBSERVER*</div>

Denise confronts our possible preconceptions, and elegantly reveals the complexities of procreation, dispelling the notion that bearing children is an absolute. The accompanying quotes inform us of the infinite expanse of conditions that we might not have considered.

Mum's not the word is a deep, thought-provoking, meaningful and concerned documentary.

<div align="right">BEN EDWARDS, FILMAKER/PHOTOGRAPHER</div>

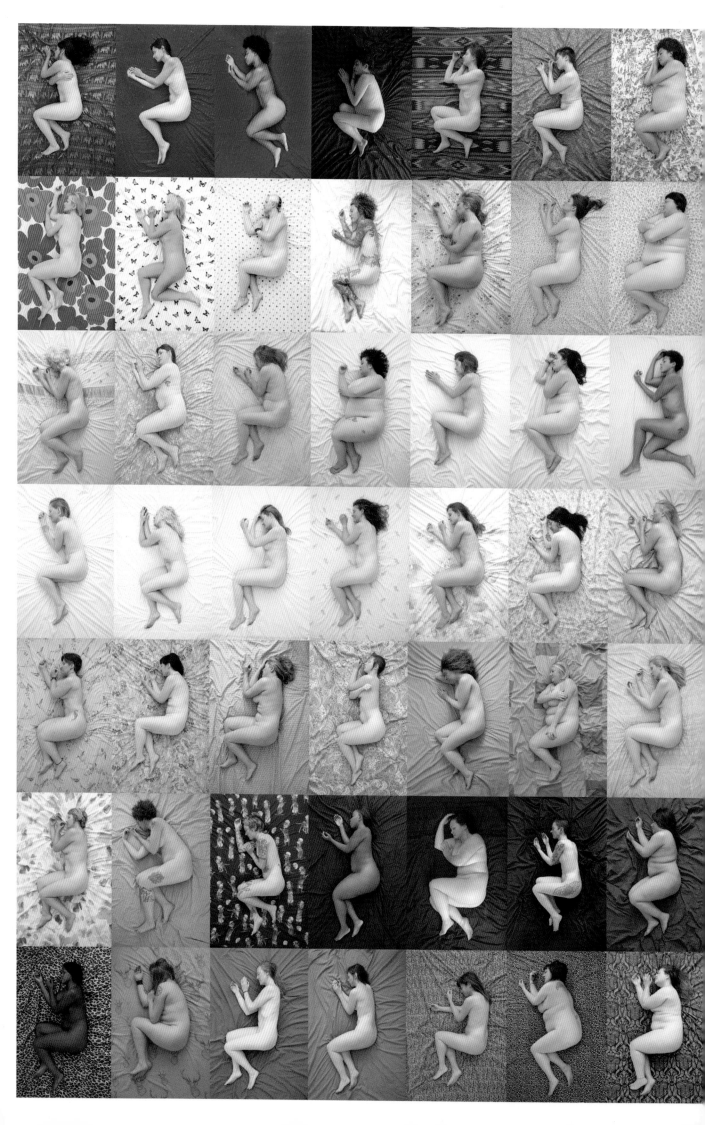

Contents

Foreword

by Susan J Mumford

In Denise Felkin's *Mum's not the word*,[1] we bear witness to fifty women who are literally and figuratively making bold statements by baring all. In this series of portraits, each image is accompanied by personal testimony of the sitter. The subjects are not mothers, and nor are they staying silent about this facet of their identity – not any longer, at least. These testimonies demonstrate a selection of societal complexities and personal circumstances of women who do not have children, with the aim to honour and celebrate *all* women, no matter their parental status.

Following many years' research and planning, the photographer sensitively captured the portraits in her studio in Brighton, England. Positioned in a striking foetal position, each subject was invited to provide a statement about being childless or childfree. Common themes emerged, ranging from concern about over-population of the planet to ongoing hope that a child may be possible in the future.

Denise set to pursuing this project as a way to "change attitudes and break down stereotypes about women who don't have children." Some of the sitters see the project as helping to pave an easier road for women of the future. How? Consider the following remarks that I've personally received from other women, upon the discovery that I don't have children –

"You'll regret it someday."

"My life wasn't complete until I had children."

"Who's going to look after you when you're old?"

Writer Chanel Dubofsky writes in Rewire.News:[2] "While it's somehow become socially acceptable to ask everyone you come across if they have children, and if not, why, this doesn't make it easier to disclose a complicated answer, which everyone has to a certain degree."

What's the distinction between childless and childfree? Sociology professor Amy Blackstone[3] states –

"Childfree: A conscious choice to opt out of parenthood

• Early articulators: know from an early age that they do not want kids

• Postponers: put off deciding until their childbearing years have passed
Childless: Someone who wants children but does not have them"

In an informal survey conducted on the subject, I discovered a multiplicity of interpretations. For example, some view childfree as being those with grown-up children who have flown the nest, whereas others see it as being devoid of the onus of having and raising children. There was consensus that childless suggests a lack of something, and that childfree implies one is not burdened by an onerous responsibility. A stand-out comment was that the mere existence of the terms suggests that the default assumption is that a woman is a mother.

Does the distinction matter?

A recurring theme in my survey was a resistance to the necessity of such terms – and yet, humans commonly categorise others in order to understand them. The very existence of 'World Childless Week' and 'International Childfree Day' indicates a desire to gather with others of one or the other as a shared identity; thereby creating a community of individuals who understand and can support one another. Moreover, the differing experiences of the two are striking.

Childless women can find it upsetting to be around happy families, particularly in the early days of adjusting to this reality. They might also be unable to comprehend why a woman who is able to bear children doesn't do so. While other options such as adoption may be available, successfully going through pregnancy to full term has been a life-long plan. Changing this life-long intention takes time, and can be difficult.

Childfree women often find themselves confounding others who don't understand why a woman would opt out of parenthood. They might find themselves defending this very personal decision, in an attempt to help others accept that the choice is theirs to make.

The specification of the terms is timely, as the introduction of the contraceptive pill is still in living memory (developed in the 1950s and released in the 1960s). It's often described as one of the most significant medical advances of the 20th century.[4] Several generations into regular use of the pill, and society is increasingly differentiating between the circumstances that result in a woman who is not a mother.

It's no surprise, then, that many of the women photographed for *Mum's not the word* found the experience to be empowering. The publication presents a timely opportunity to educate others, and pave the road for future generations.

Where does this leave us?

You're invited to take in the powerful images and accompanying statements with respect for each individual. Whether childless or childfree, mum is *not* the word, and all of the women sensitively presented in this volume have taken part to raise awareness and help women of the future. As for now, it's your turn to digest and spread the word, too ...

Courtesy Chris E King

Susan J Mumford

www.susanjmumford.com // @susanjmumford

[1]Definition of 'mum' (British English): one's mother. English Oxford Living Dictionaries.
<https://en.oxforddictionaries.com/definition/mum>
[2]Chanel Dubofsky, Childless or Childfree: The Difference Matters, Rewire.News. 8 May 2014.
<https://rewire.news/article/2014/05/08/childless-childfree-difference-matters/>
[3]Amy Blackstone, Childless ... or Childfree, SAGE Publishing. 20 November 2014.
<https://doi.org/10.1177/1536504214558221>
[4]Sarah Bridge, A history of the pill, *The Guardian*. 12th September 2007.
<https://www.theguardian.com/society/2007/sep/12/health.medicineandhealth>

Introduction

"In primordial times women were sacred drummers, which came about as the pulse in our mother's blood was our first continuous experience, and we quickened in the womb. The female bleeds with the rhythm of the moon. If she does not discharge blood and other material from the lining of the uterus as part of the menstrual cycle for ten cycles of the moon, her blood is transformed into a new being. Our physical being formed in response to the rhythms of her body bonding the individual with the rhythms of the community, environment and cosmos."

LAYNE REDMOND, *WHEN THE DRUMMERS WERE WOMEN*

The naked girl with red hair lies on her wrinkled black-and-white duvet. Alone, eyes closed, and choosing comfort in the foetal position, she wears a simple tattoo on her shoulder. The photographer has chosen to shoot from above. The viewer has been allowed to be distant yet intimate with her. Who is this angel who has fallen to earth?

Women who do not procreate are too often misrepresented by stereotypes: barren, spinster, half-woman, wicked stepmother or crazy cat lady. On many occasions, I have heard people say: "You wouldn't understand unless you are a parent yourself," asserting a premise that suggests that females who do not reproduce are selfish, do not like children, or are not 'real' women.

I conceived this book because I do not have children: I label myself 'childfree' because I did not want to have them. I use photography to challenge negative attitudes about the stigma that those who don't have kids bear. Being infertile is not usually a choice, however, and can be a traumatic experience: possibly a grieving process, that, for some, may slowly slip into acceptance, or a cause of lifetime pain and anguish. And then there are those who are childless due to circumstance or disability.

In 2018, the Office of National Statistics recorded a continually-expanding population of seven billion people worldwide, with four hundred thousand births per day. The decision to reproduce is not considered to require any thought or justification, it seems to me, whereas childless women are expected to 'explain themselves.' One in seven couples can't have children, and twenty-five percent of failures to conceive are medically unaccountable. *Mum's not the word* highlights the social stigmatisation of those women who, by choice or for medical reasons, go against the instinct of childbirth and maternal productivity.

I began this project in early 2015, and, over a period of four years, fifty women volunteered to be photographed. I found participants via friends, acquaintances, word-of-mouth, and social media. I discovered that there is more pressure on women of black minority/ethnic cultures to have children; some who had volunteered dropped out at the last minute. An Asian woman had to withdraw before the shoot because she was pregnant; an Indian female decided against being involved because she still hopes for a child, and a Muslim woman because of her religious beliefs. The book's participants are mostly from the UK; living in Brighton, London, Essex, the Isle of Wight, the West Country, Leeds, and Birmingham, whilst some of the models originate from Germany, Hungary, Greece, Puerto Rico, Barbados, Finland, Romania, and Australia. Some women identify as trans- or neutral-gender. I have attempted to be representative of womankind, whose overall consensus about their childless state is a mix of empowered, grateful, neutral, accepting, and heartbroken.

Mum's not the word presents the raw images of nude women in the foetal position, strongly suggestive of the possibility of life through child-bearing, whilst also prompting feelings about wider issues, such as the environment and population growth.

I believe that one of the benefits of not having kids is that this helps to protect the future of the Earth, which is critically compromised: not only are our natural resources

running out (with no viable alternatives), but our wildlife is waning to the point of extinction. In conjunction with globalisation, the world has become over-populated, and social cultures and familial structures are breaking down. As the population soars, a growing number of human and wildlife communities will continue to decline and be displaced due to climate change, environmental disasters, war, famine, technology and industry.

Those who live their lives without descendants create much less of a global strain. One in five women born during the 1960s, and one in four born during the 1970s do not have children. The childless, childfree, childless by circumstance or disability are becoming a newly-recognised breed of women, who positively contribute to reducing the human impact on the natural world.

Is it possible that civilisation can be guided to recognise that it is acceptable to opt out of parenthood, and, by not procreating, find that humankind can inherit the key to a sustainable future ...?

"In the process of creation the divine mother is a powerful mythological symbol; she is an archetype of the eternal female. The Earth itself was revered as the Great Mother of All That Is, because new life comes from women's bodies, as it did from the earth."

LAYNE REDMOND, *WHEN THE DRUMMERS WERE WOMEN*

Courtesy Kiki Streitberger

Denise Felkin

Acknowledgements
Thank you to all the contributors, with special thanks to Kit Collier Woods for their continuous support since I began *MNTW* in 2015, Antonia Thompson for guidance with the intro, and Sophie Batterbury for the feature about *MNTW* in the *i* newspaper, 9th January 2018

Awards for Mum's not the word

Honourable Mention: The Photography Gala Awards special edition of Julia Margaret Cameron: Women Seen by Women (2018)

Finalist: National Open Art Competition. MS Amlin Sponsored Prize 'Continuity in an Uncertain World' (2017)

Finalist: National Open Art Competition (2017)

Finalist in Editorial & Documentary category: 10th Julia Margaret Cameron Award (2017)

Finalist in the Documentary category: 9th Edition Pollux Awards(2016)

Nominee Award in People category: Photogrvphy Grant and Magazine (2016)

Finalist in the People category: Sony World Photography Award (2016)

Website: denisefelkin.com
Instagram: denisefelkinphotographer
Facebook: Denise Felkin Portrait, Editorial & Documentary photographer
Twitter @denisefelkin

I am the youngest of four sisters born into what became a single-parent family. I observed my widowed mother raising us on her own, and realised from a very early age that I did not want to experience the life of a parent when I grew up.

When I was 19, I spoke to my mother about this for the first time – she dismissed it, telling me I would feel differently when I was older; I never did.

Denise

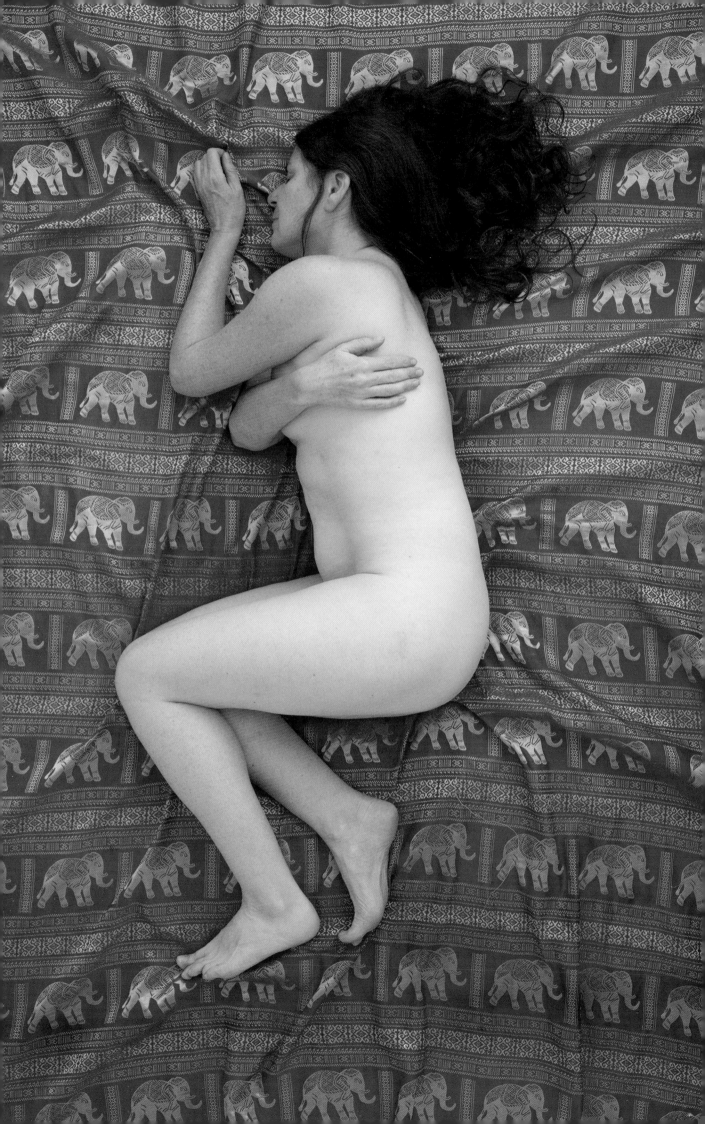

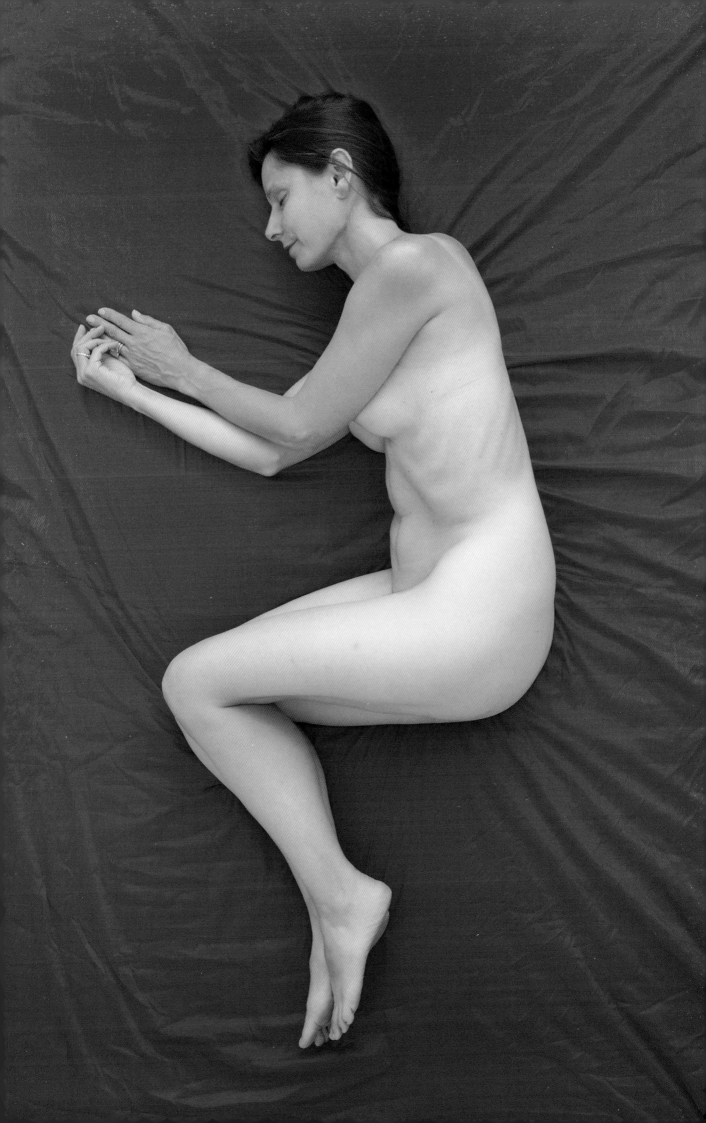

Not having a child has been a loss that has made me face death. In the Palaeolithic, the dead were covered with red ochre, placed in a foetal position facing towards the sun, then buried beneath where they normally slept when alive.

Xanthe

I never thought I would get to 45 years of age with no children or partner. Sharing my childless experience on my YouTube vlog helped me immensely, but whenever I think I'm over it, someone posts their new baby pic online and my heart aches. I don't think that will ever go away.

Anthea

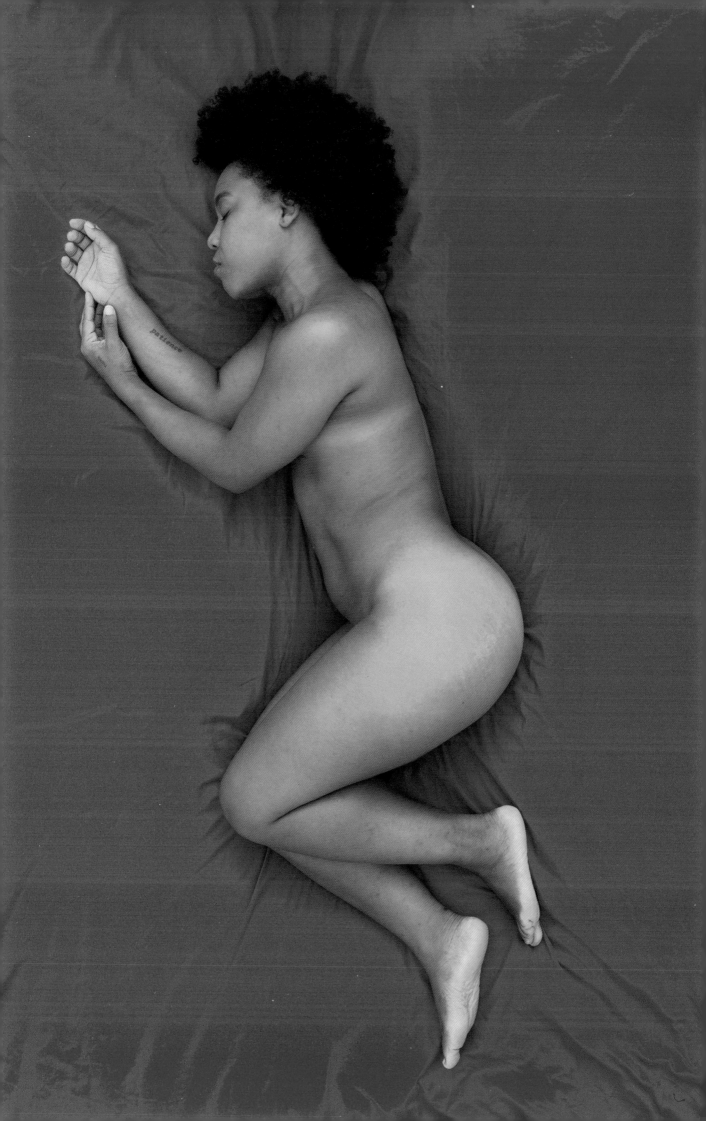

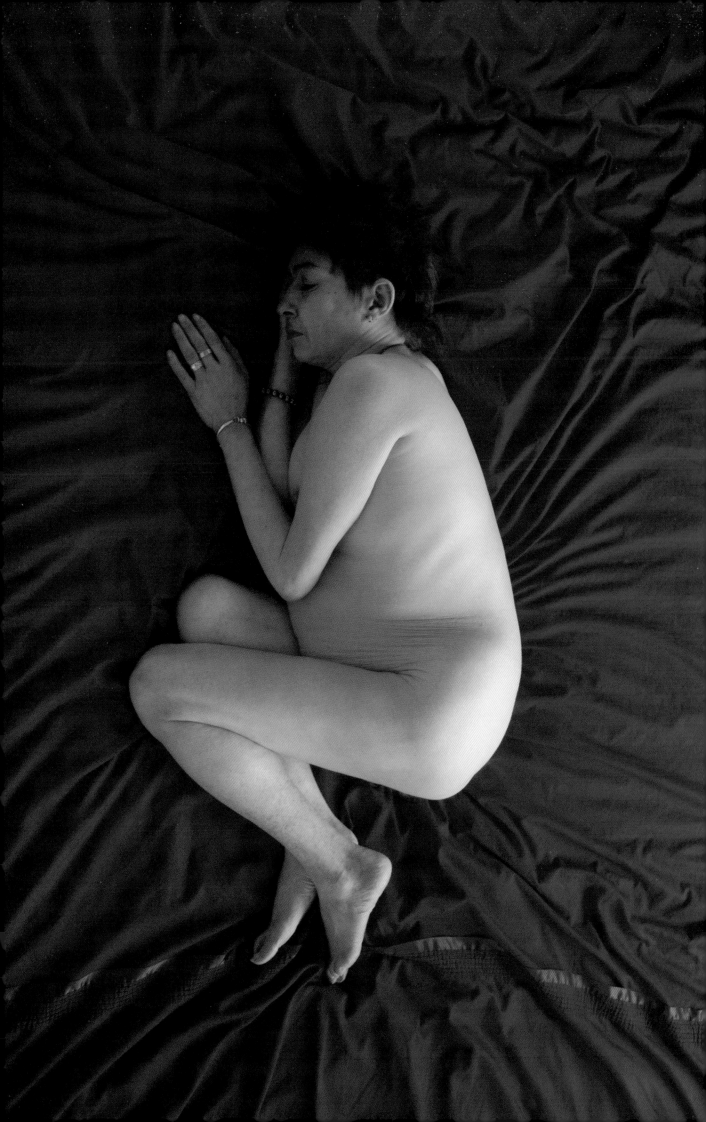

It never appealed to me.

Jennifer

When I was younger my friends were always talking about their future kids. I was never interested in this subject. My answer was always "I will not have kids. Not in this society." Today, I think the same.

Veronika

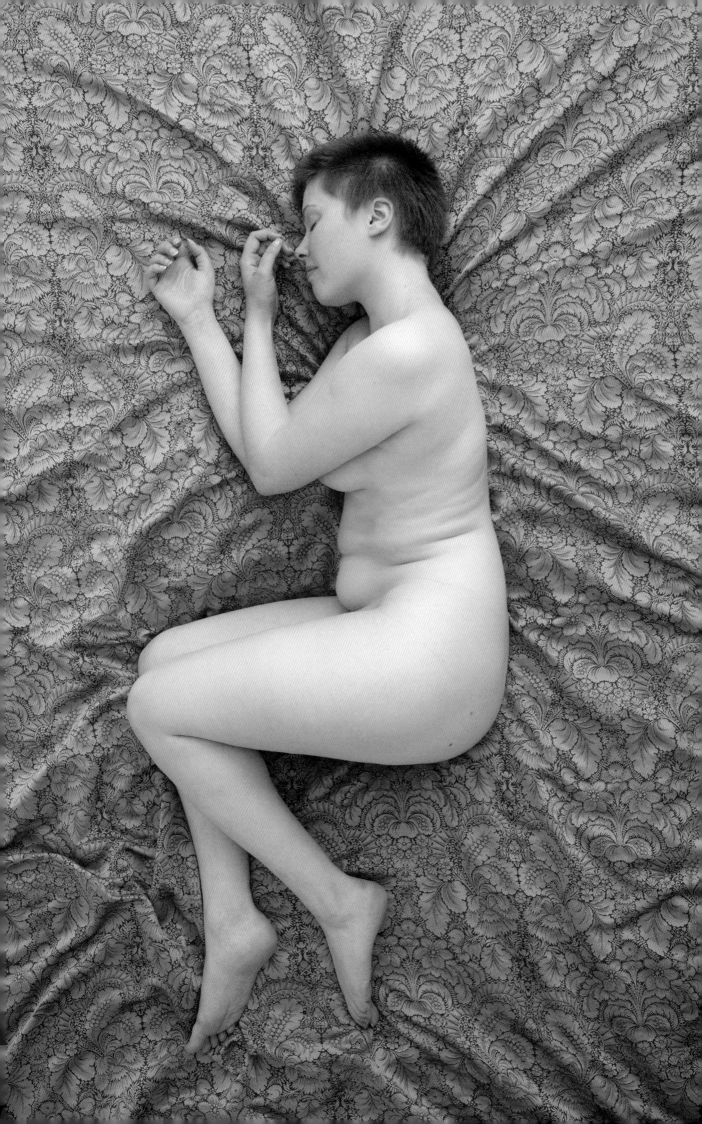

At first I thought when I found the right partner everything would make sense, and my sexual desire would 'switch on.' I've been in several long-term relationships with people I really loved, harbouring this secret that I don't enjoy or even want sex.

Every asexual experience is different. I know some asexuals are interested in adoption, but kids have never been something I wanted. I was the eldest child in my family, and most of my work involves being around children, so I feel like I've done my time as a caregiver!

Amy Louise

My mother was 18 when she had me. My grandparents kicked her out of the house, and she raised me on her own. I've never been broody, and never met anyone I loved enough to make such a huge sacrifice for.

Amy

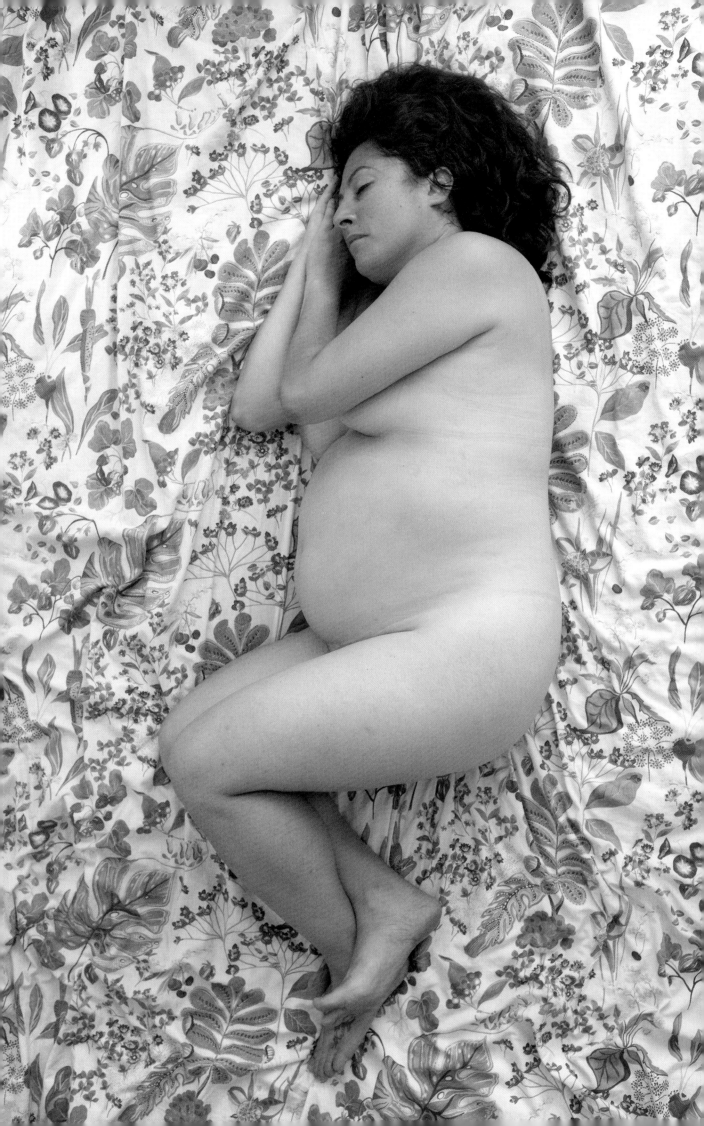

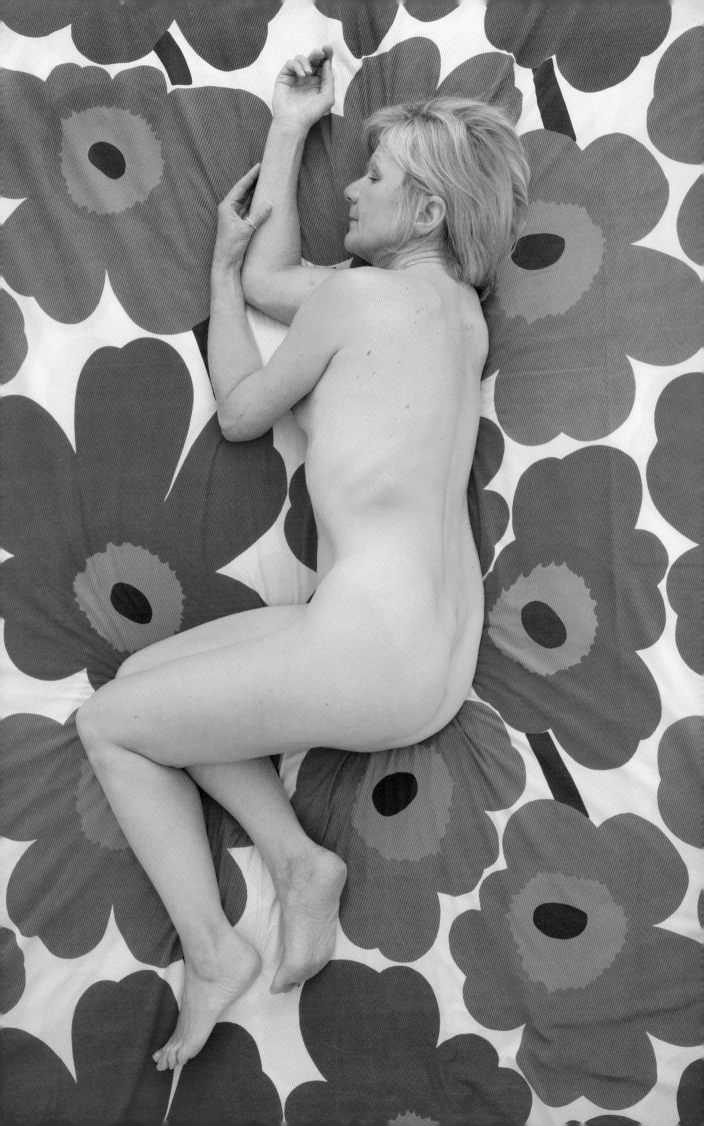

Time and circumstances decided for me, really. My partner at the time already had fairly grown-up children, and we were busy building a life and a business together. A degree of ambivalence also played a part.

At this stage in my life, I find myself thinking that it would be nice to have grandkids to love and do daft things with, and with whom to share the life-experience I have.

Jude

Until I grieved for the children I never had, my inside world and my outside world were very disconnected. I hid my pain. Now I can be me, vulnerable 'n' all, and embrace the whole gamut of emotions that is this beautiful life, both for myself and with others.

Lauren

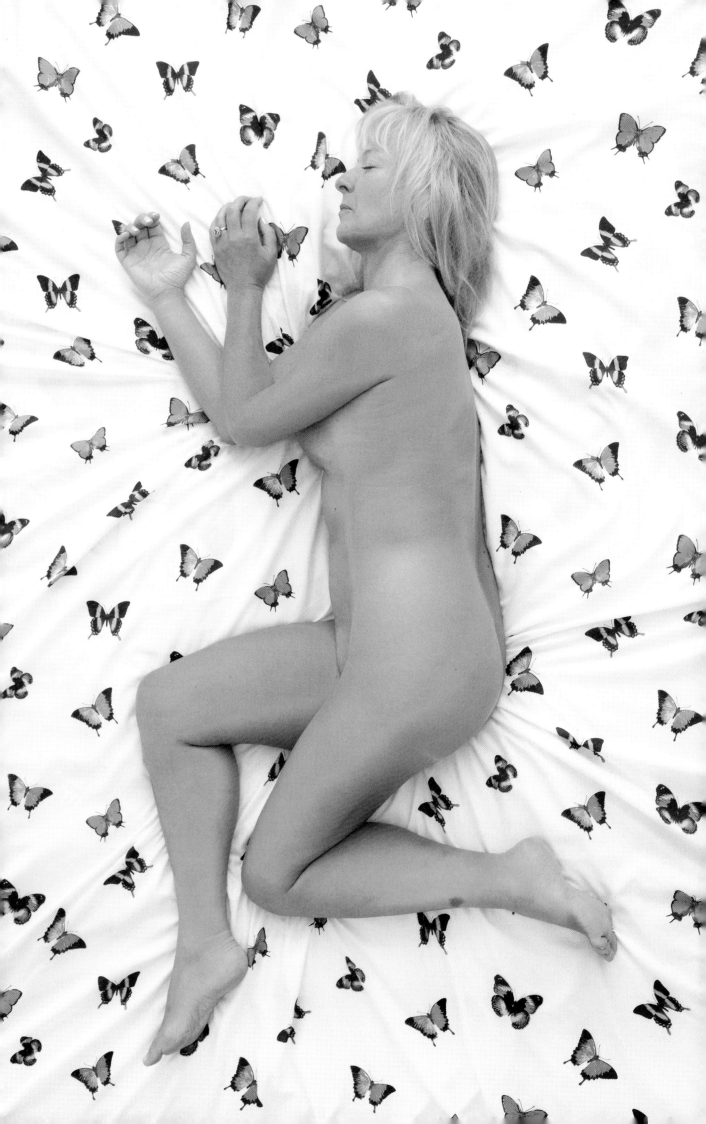

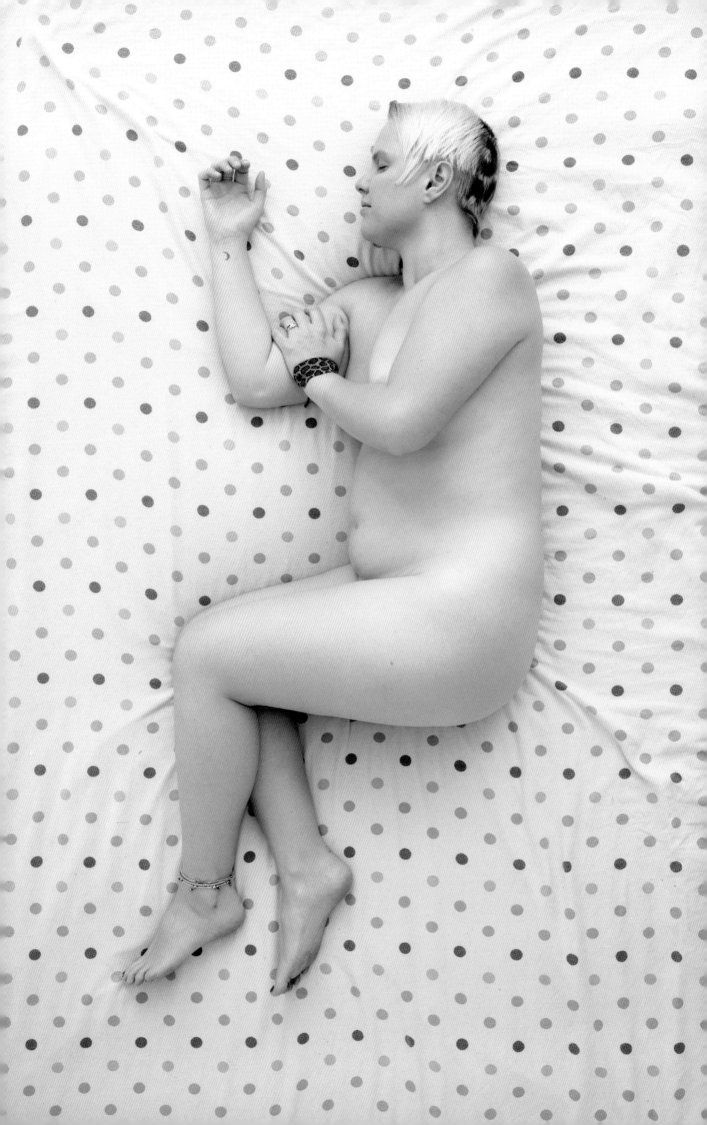

My husband and I did IVF three times, and were trying for six years before deciding that enough was enough, and to move on with our lives.

The universe clearly had other plans for us because the moment we walked away from that unbelievably painful hunger, our lives began to flourish. I'm now a theatre-maker, published author, and international jetsetter. My husband runs his own laptop repair company.

Jolie

I never wanted kids. The idea of something growing inside me like a parasite felt wrong to me. Although I love kids, I'm still a child myself. I still believe one day I will foster a child.

Kate

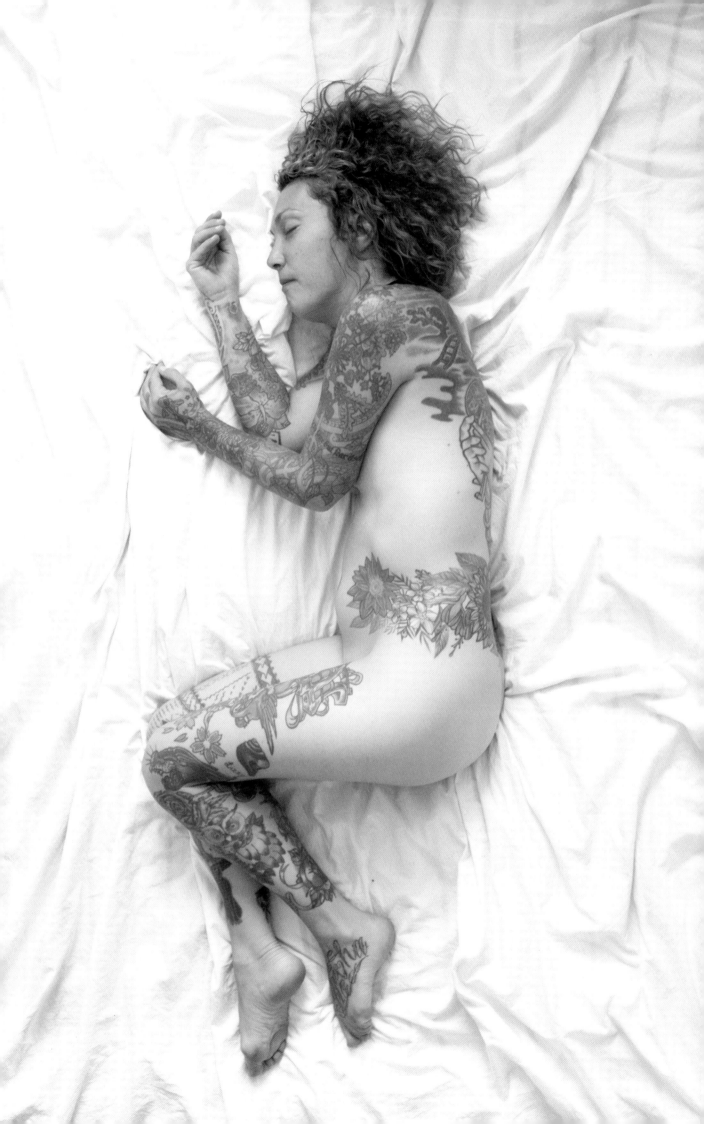

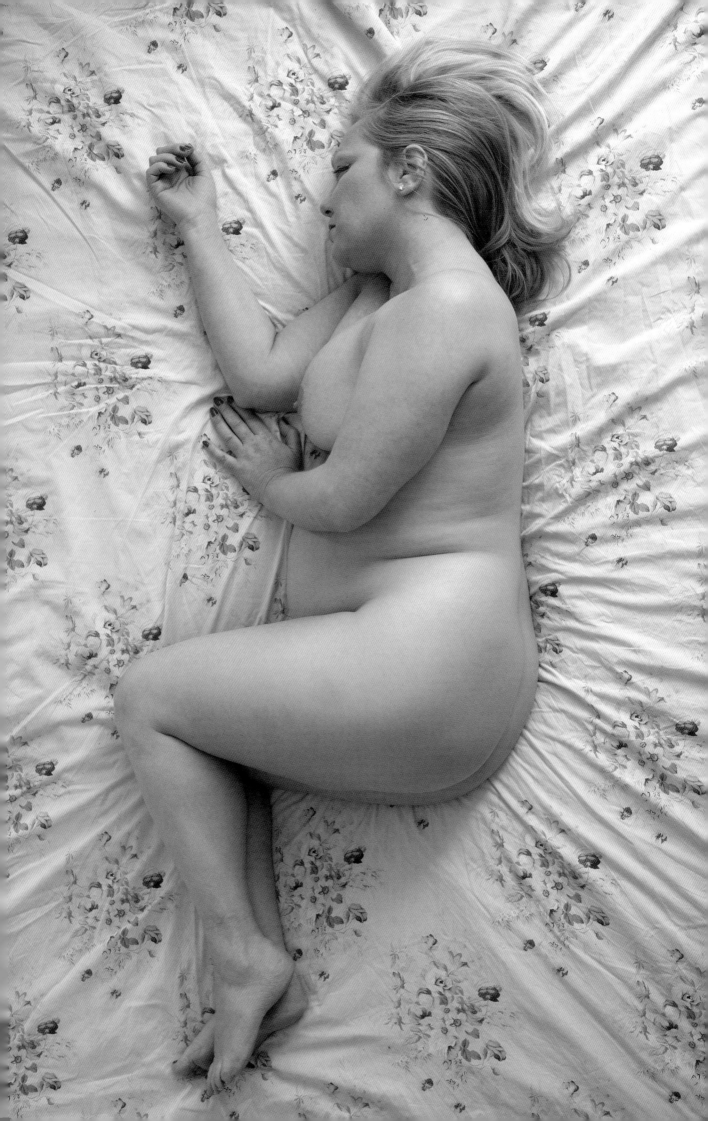

I watched my mother struggle with three young children when I was in my teens. I decided then it was not for me.

Becca

I have endometriosis. My latest surgery was seven weeks ago and I'm still recovering. There would be so much more to my story, but when simply looking at 'why,' then endo is my main reason. (I wanted to say 'latest' to explain that the endometriosis is ongoing.)

Sari

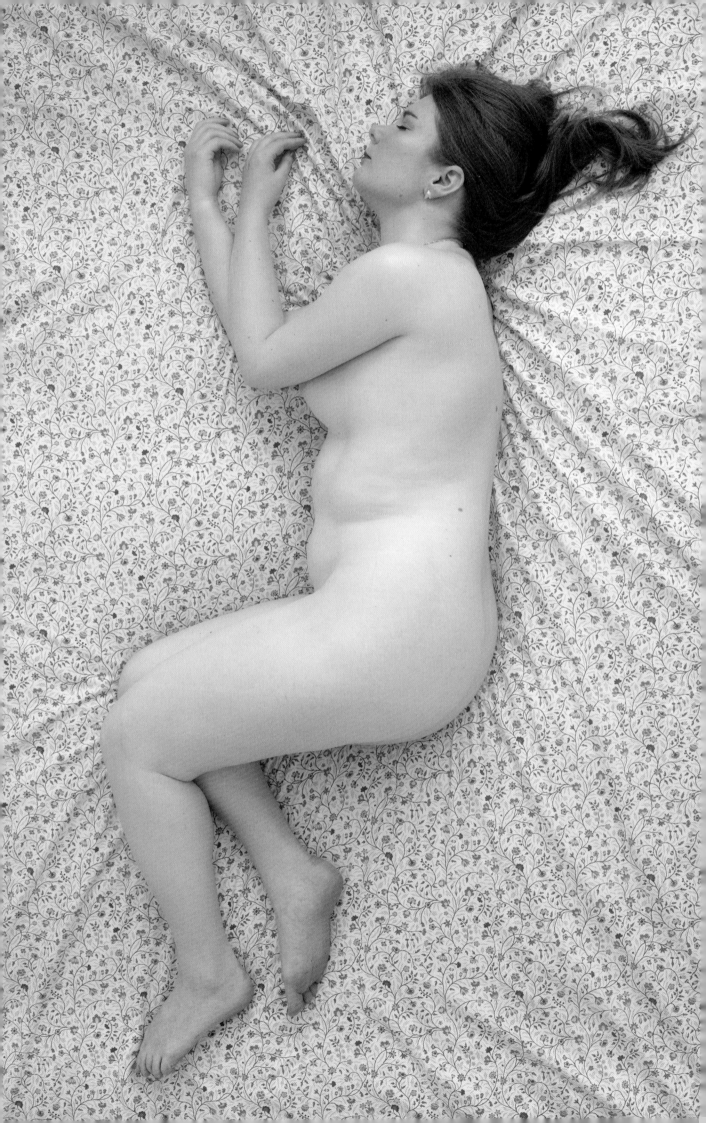

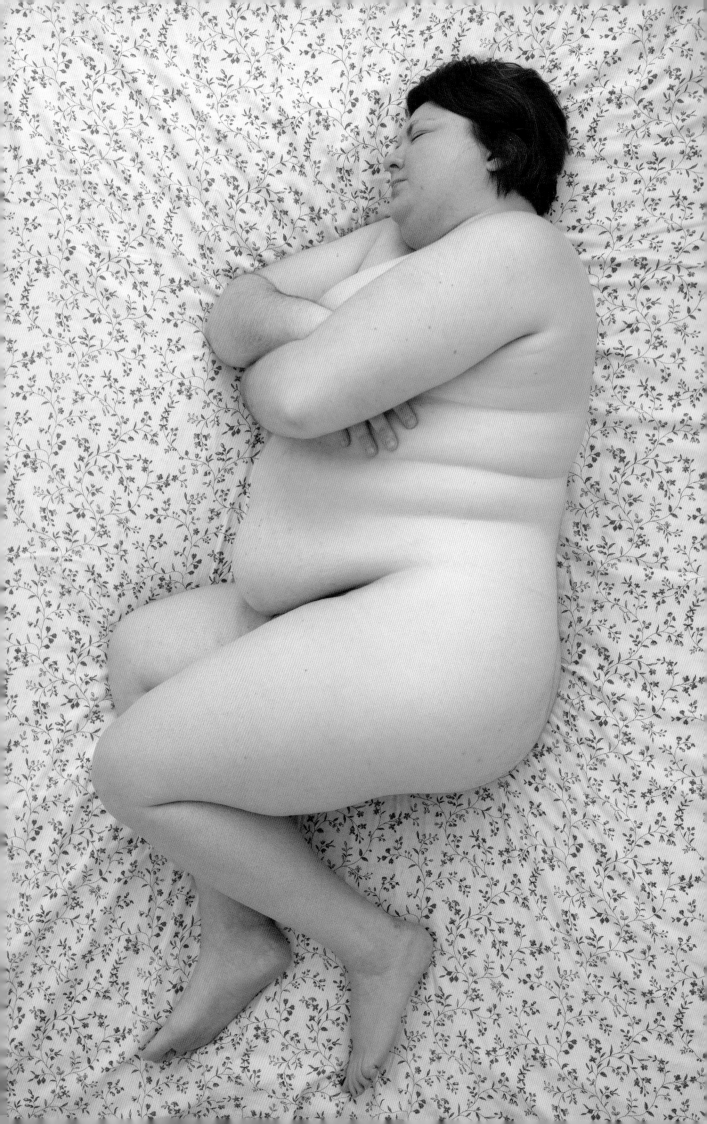

If I'm honest I have never felt the want or need to have children. When I was younger I assumed it may happen because that's what people do, isn't it?

But it's not for me. I choose not to because I don't want them. It's as simple as that.

Sarah-Lisa

I'd always thought I'd have children and, after a long-term relationship ended, I tried lots of ways to make that dream happen – IVF, a conversation about sperm donation with a colleague, and adoption. The latter process was long, arduous and intense: so many challenges from an agency that turned out to be very risk averse (not that I was a risk; the staff there were just scared).

I became worn-out with the whole process, and decided to be brave and stop.

Helen

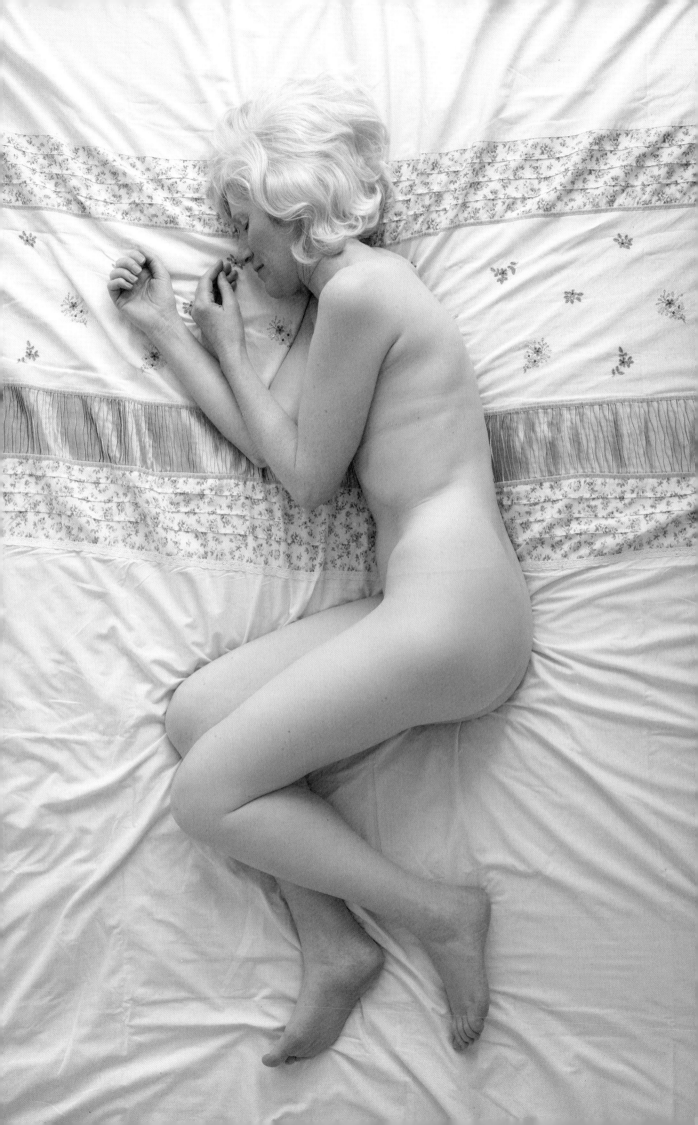

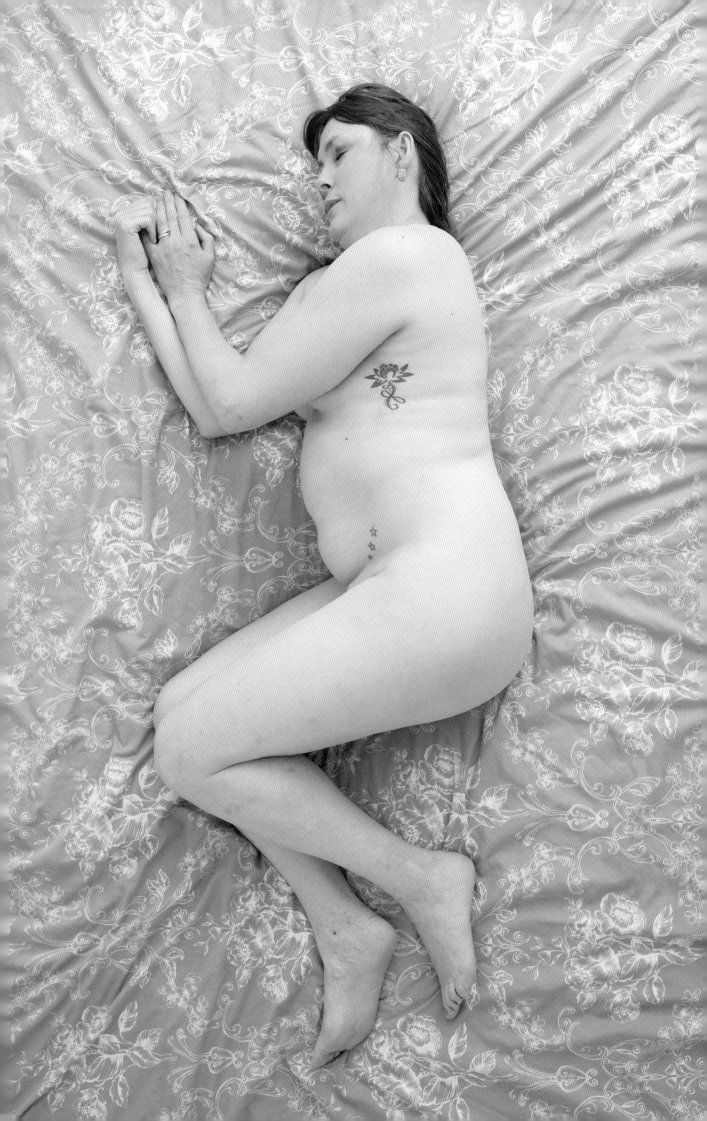

After an abusive first marriage in my 20s, it took all of my thirties to recover from it. Meeting my current husband at 40, I realised that it was too late. He has children who have their own children.

Debbie

Never in the right place at the right time with a suitable partner, motherhood passed me by whilst I put my energy into the young women I taught, and the causes I fought for.

Being childfree in retirement gives me time to devote myself to doing something to make a better future for my community, and the environment.

Chris

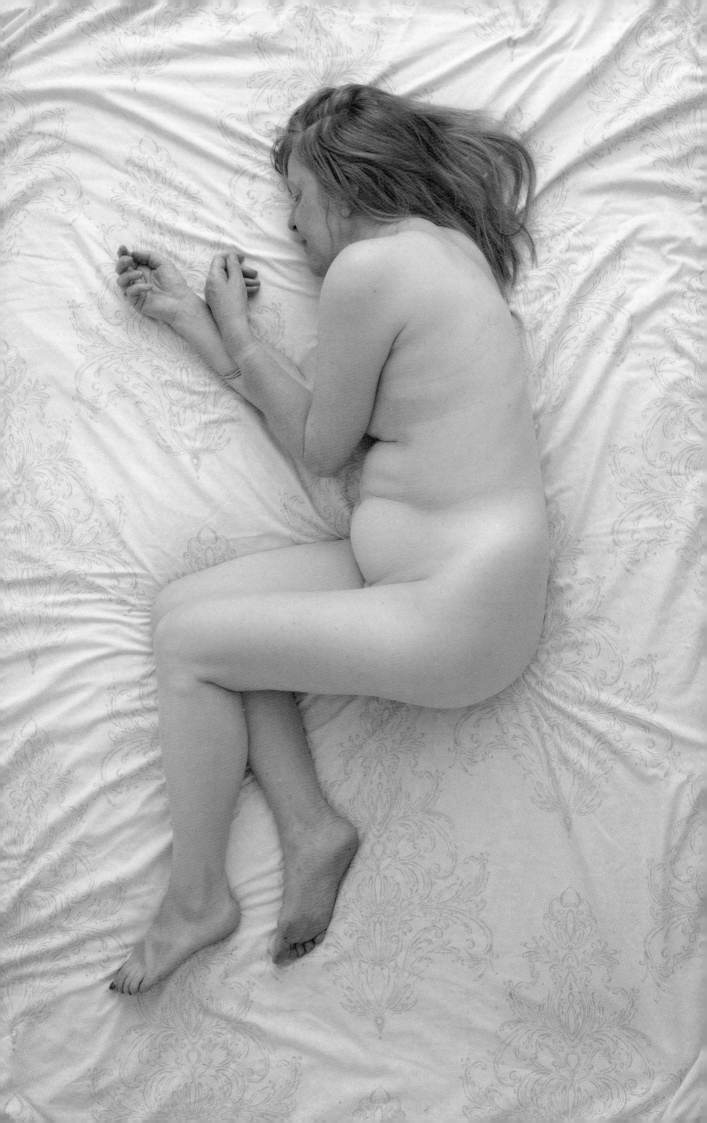

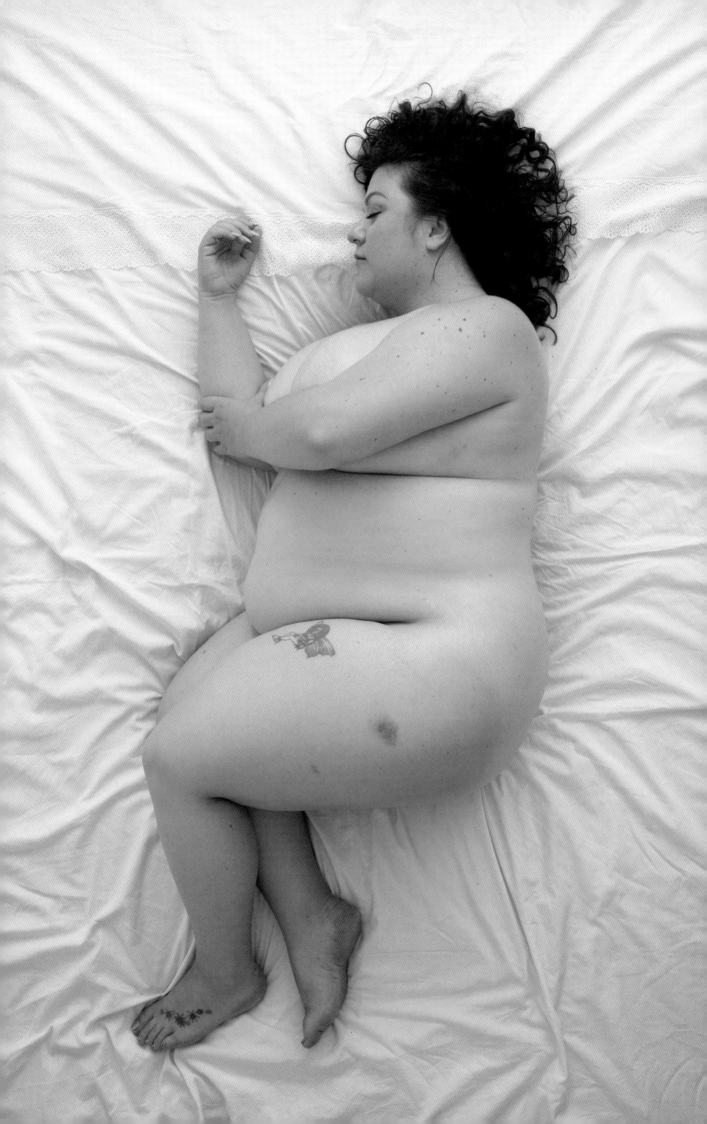

I have been told by many doctors that I probably can't have children. I convinced myself that I didn't want any, and ploughed headlong into my career. Once I'd got to the top, I worked hard and sacrificed a lot, but I found I was still lacking because all of my peers were mothers.

I don't win an accolade for working hard because I don't juggle this with being a working mum. I want to be a mum and I hope I get the chance.

Faye

I want children: however, can I have them in my late thirties and with a female partner? And how much money would I need to earn to be able to afford a decent and comfortable living?

I also question whether my family in Greece would accept me for not having children?

Calliope

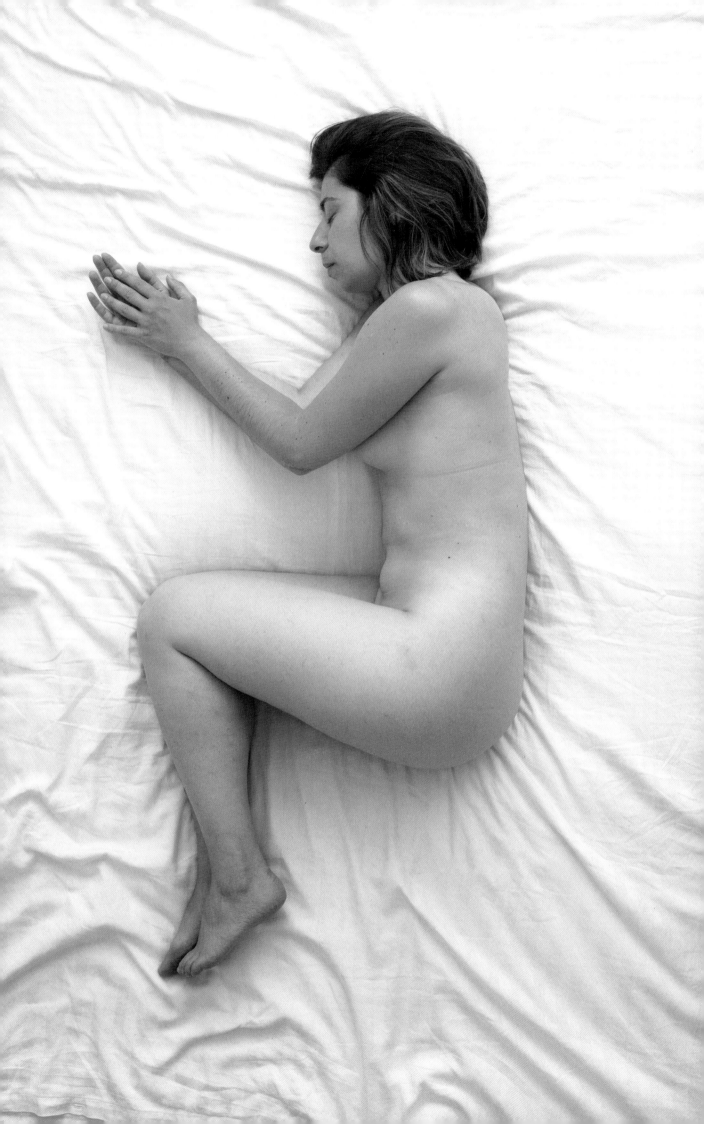

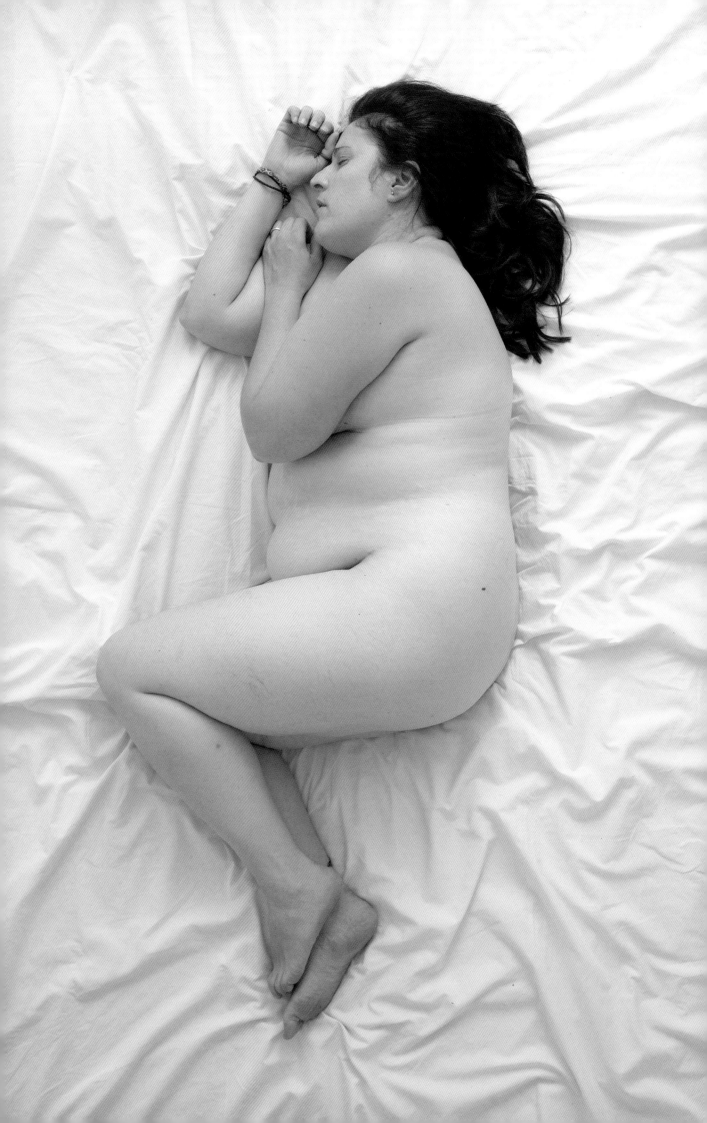

With a diagnosis of breast cancer at the age of 30 came the news that I would need five years' treatment, and my hopes and dreams of those longed-for children faded into the distance.

11 years on I am well and ever-hopeful that fate will bless me with the experience of motherhood.

Tracy

I never really expected to be childless at the age of 45. Time just caught up with me, I've been having too much of a good time to sit and think about it for too long. I hope I don't wake up one day with regret.

In the meantime, I will just keep on entertaining and taking care of my own inner child, and continue loving life.

Mel

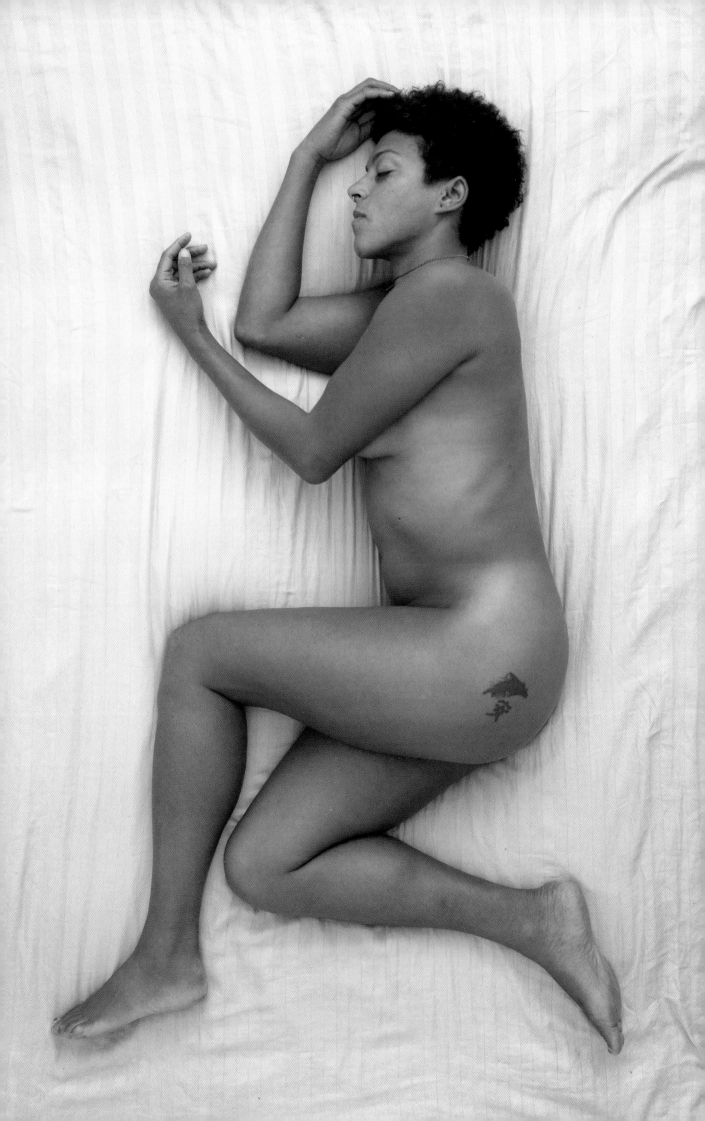

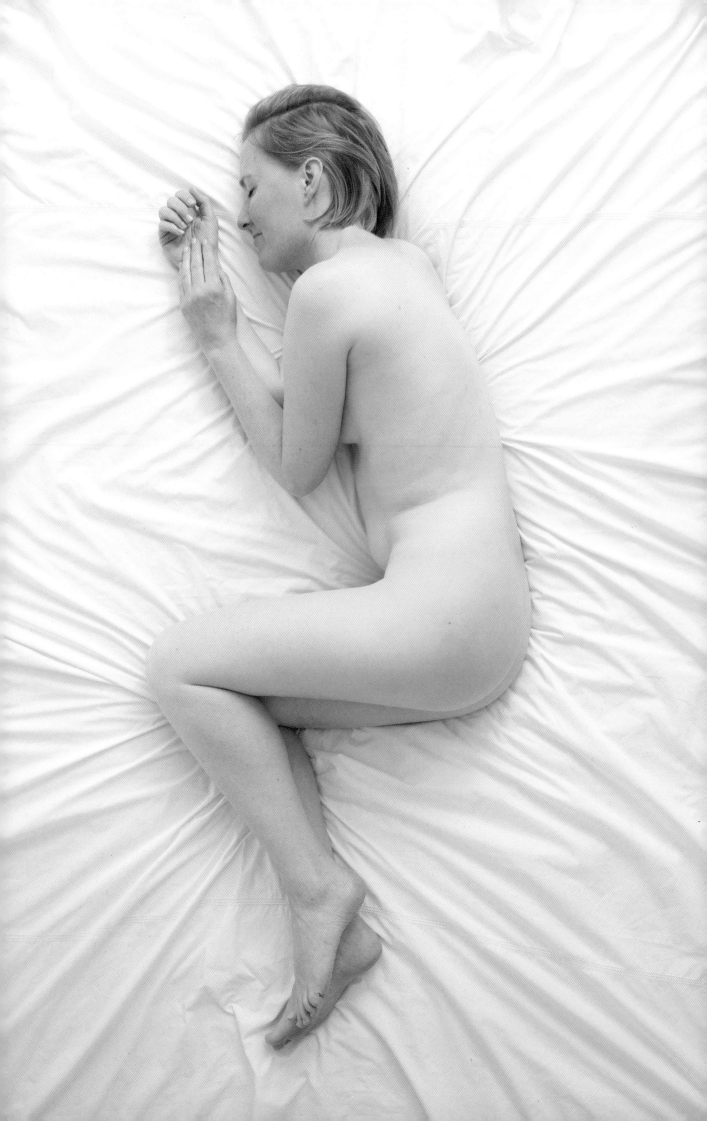

In 1994 I was diagnosed with a mild case of Multiple Sclerosis, and warned that having children can worsen the condition, but the truth is I'm not sure motherhood was ever for me. Or traditional family life. I love my life and the people in it just as it is.

Susanna

Making a statement about not having children is an alien concept. Not wanting children is part of being me, like enjoying gardening or being interested in art. Bringing up children is an important, difficult and scary job – too important, difficult and scary for me.

Kathleen

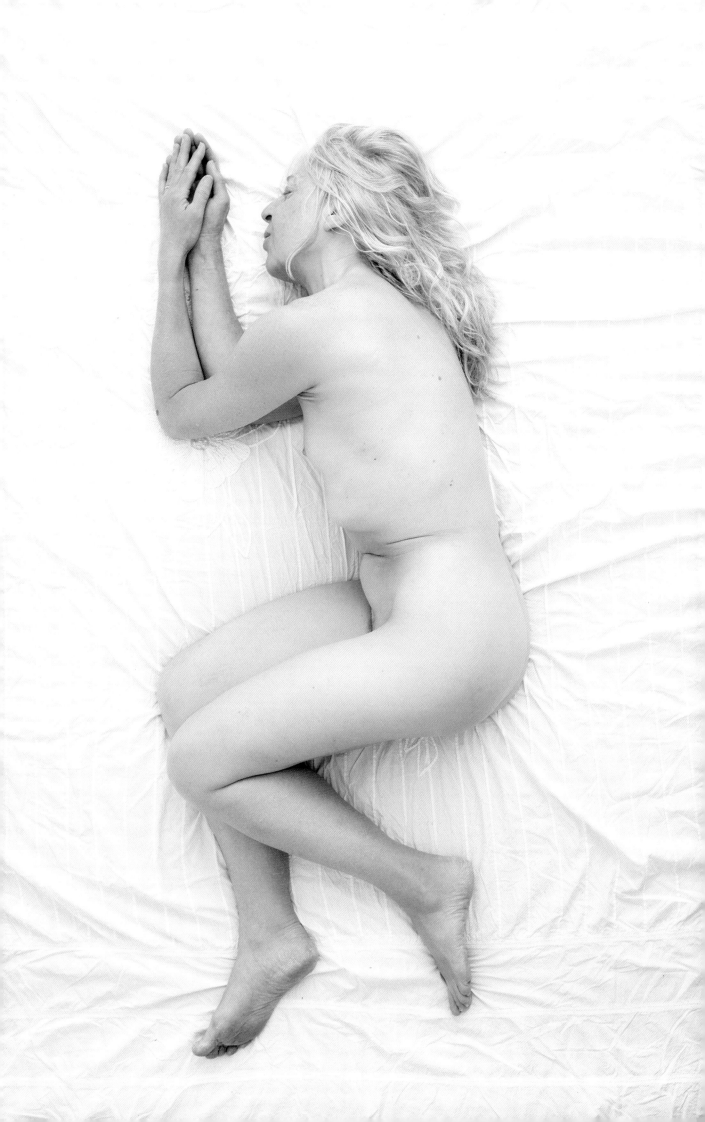

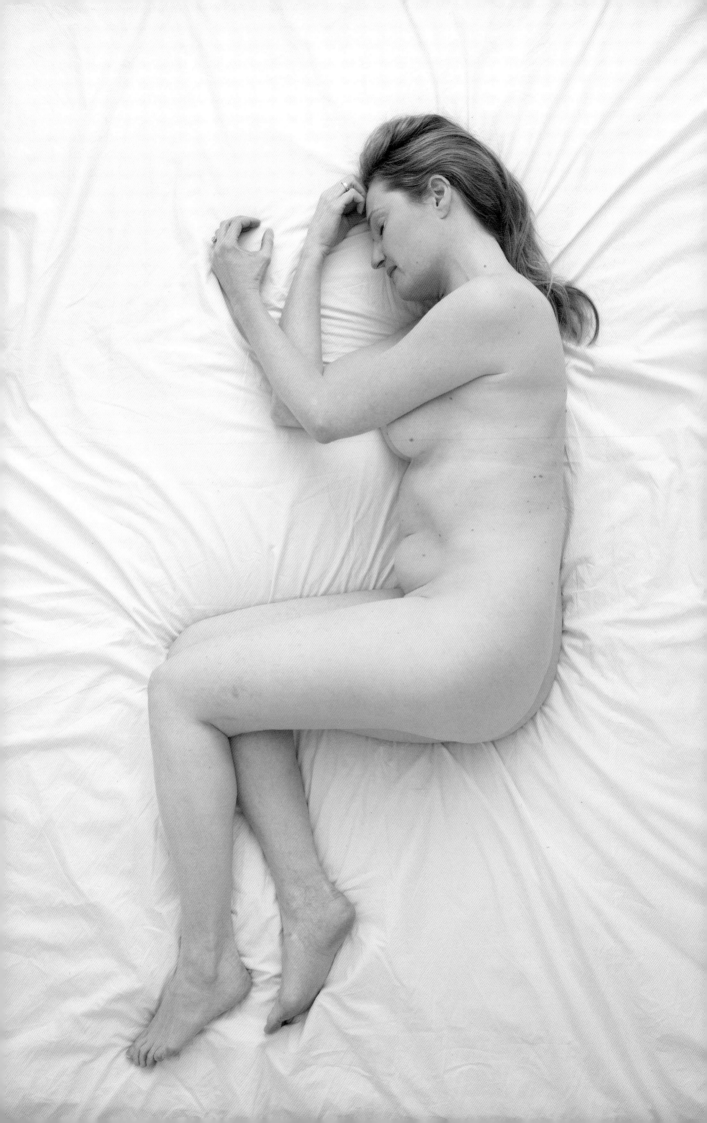

I have mourned the children I never had. When I realised having children was no longer an option, I had doubts about my decision, so taking time to reflect was important for me.

I say this in the context of the fact I never actually wanted kids, but wanted the choice. Like I might suddenly wake up one morning with the thought: you know, I think I *will* have that tattoo on my face.

Hanna

For years we tried, while all around us everyone was having babies. It's a double-edged sword: you don't want people to know that there's a problem and have them pity you, but simultaneously you want people to know – to try and understand and not make insensitive comments.

Veronica

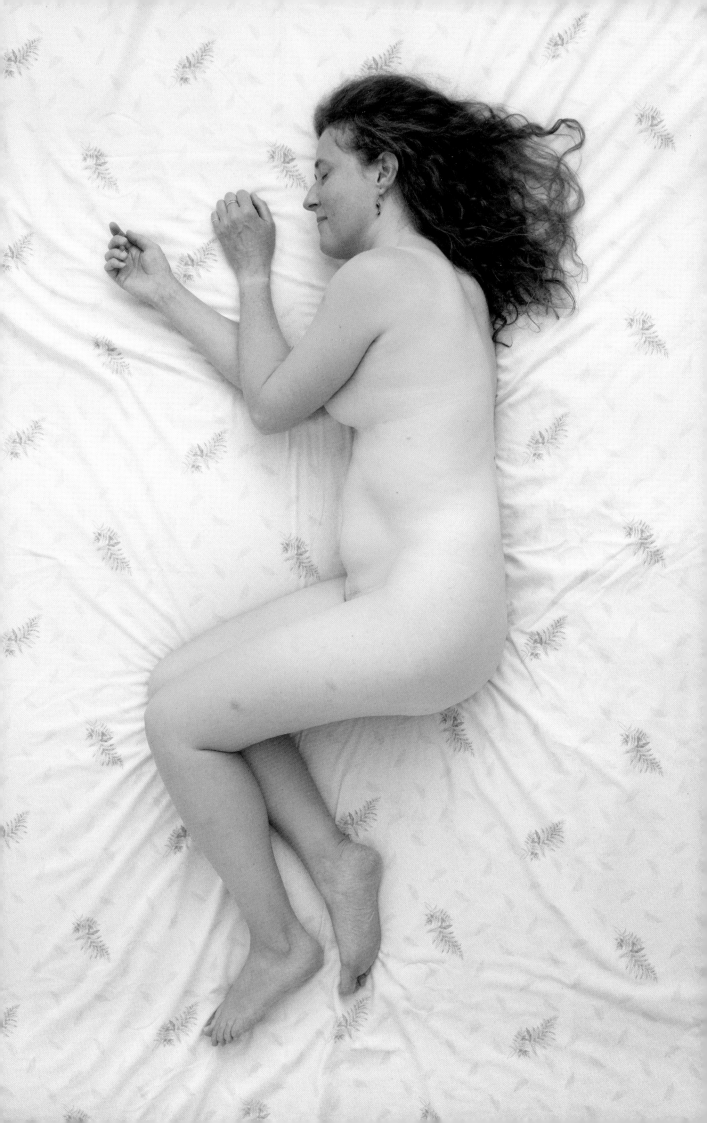

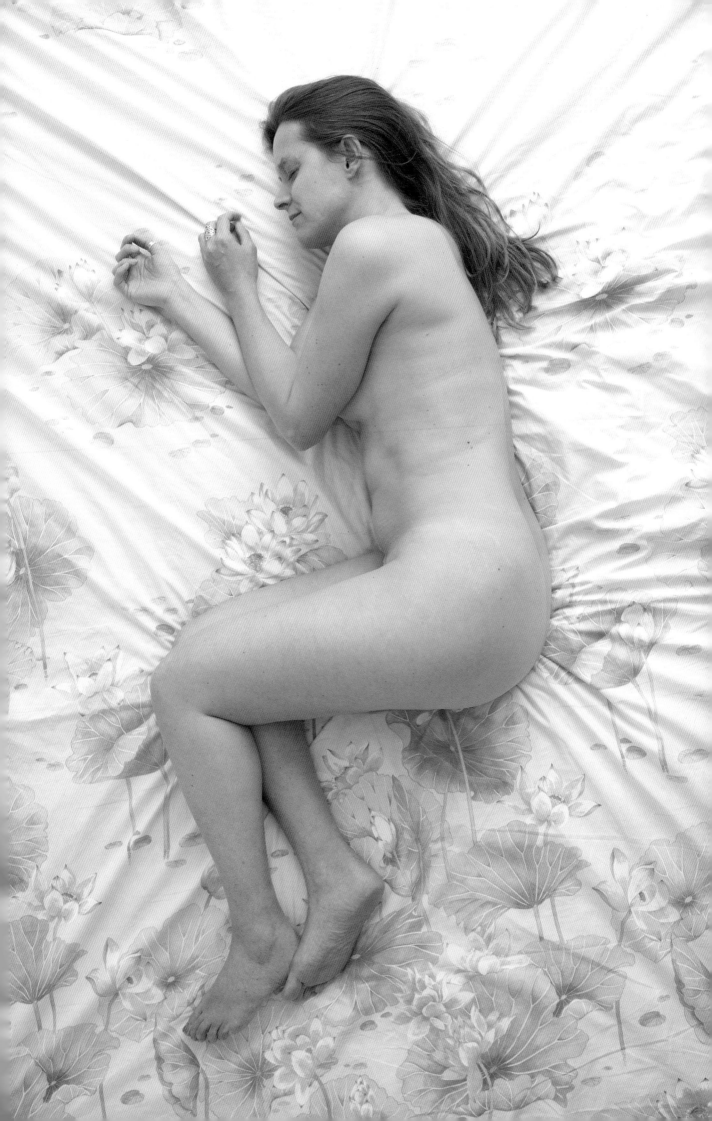

The idea of having my own child has always filled me with dread. There are too many people on the planet already, and I fear for future generations in the light of our rapidly-changing climate.

Tamara

It never seemed to be the 'right time' to have children, and now I'm mid-40s and single.

I reconcile my sadness by realising that the worst thing you can do to the environment is have more humans.

Rebecca

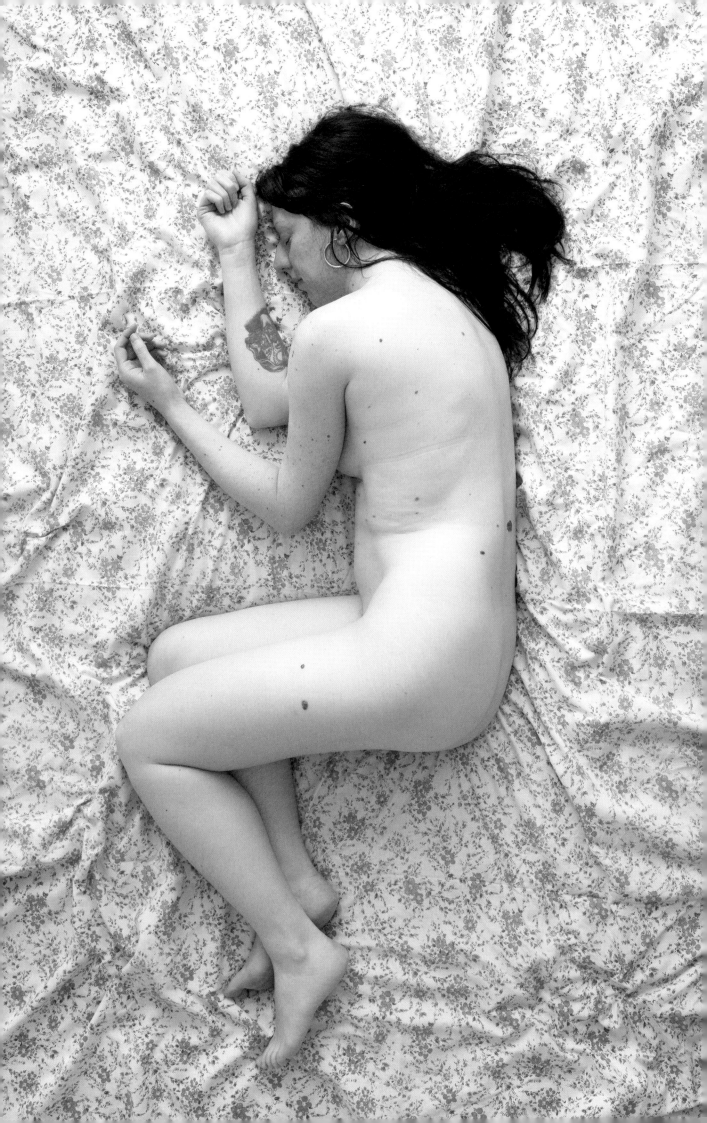

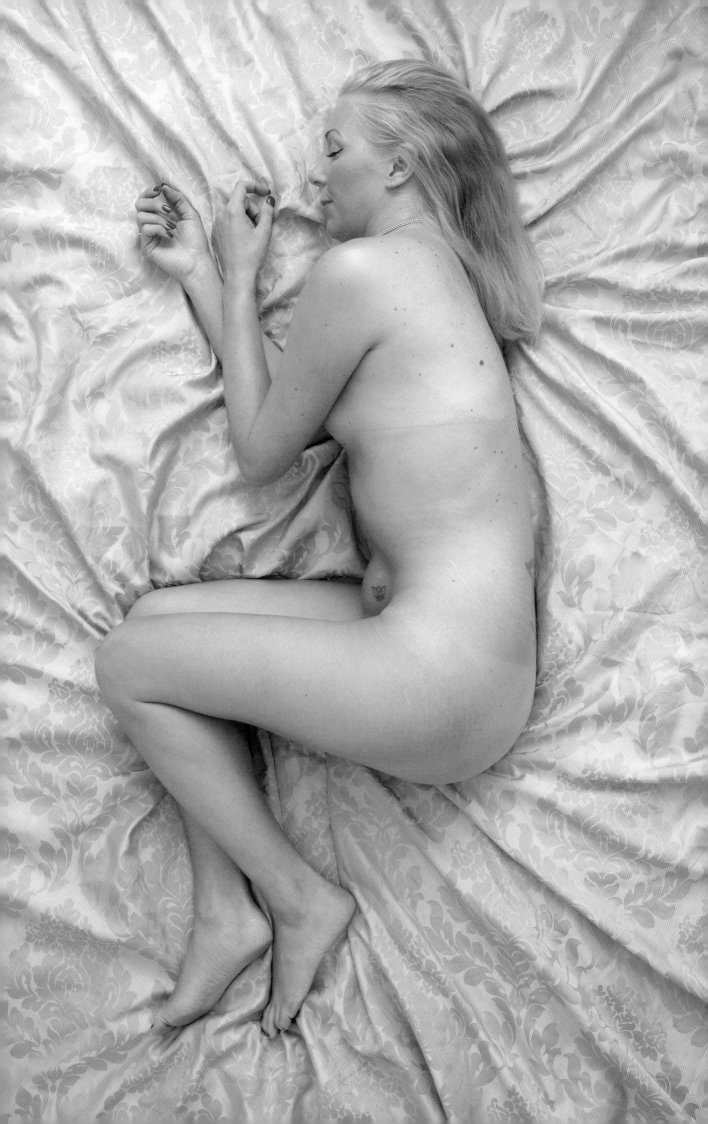

After years of trying naturally for a baby, and then with the help of several rounds of IVF, eventually it became clear that I'd never be a mother after all.

Samantha

I've never been able to answer 'Why don't you have children?' in any way that satisfied me. I try out different answers, but none fully deflects the sting of unspoken judgement – real or imagined. I can't summarise the complexity.

One truth is that I am indifferent ... and I was never ready to be an indifferent mother.

Claire

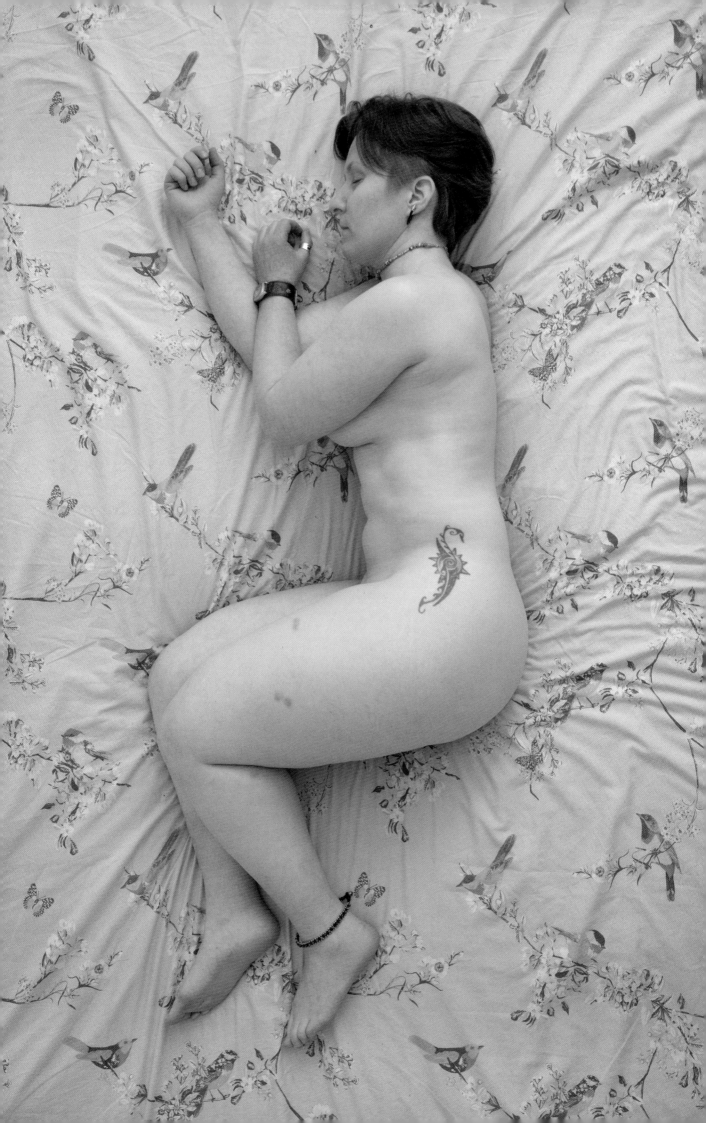

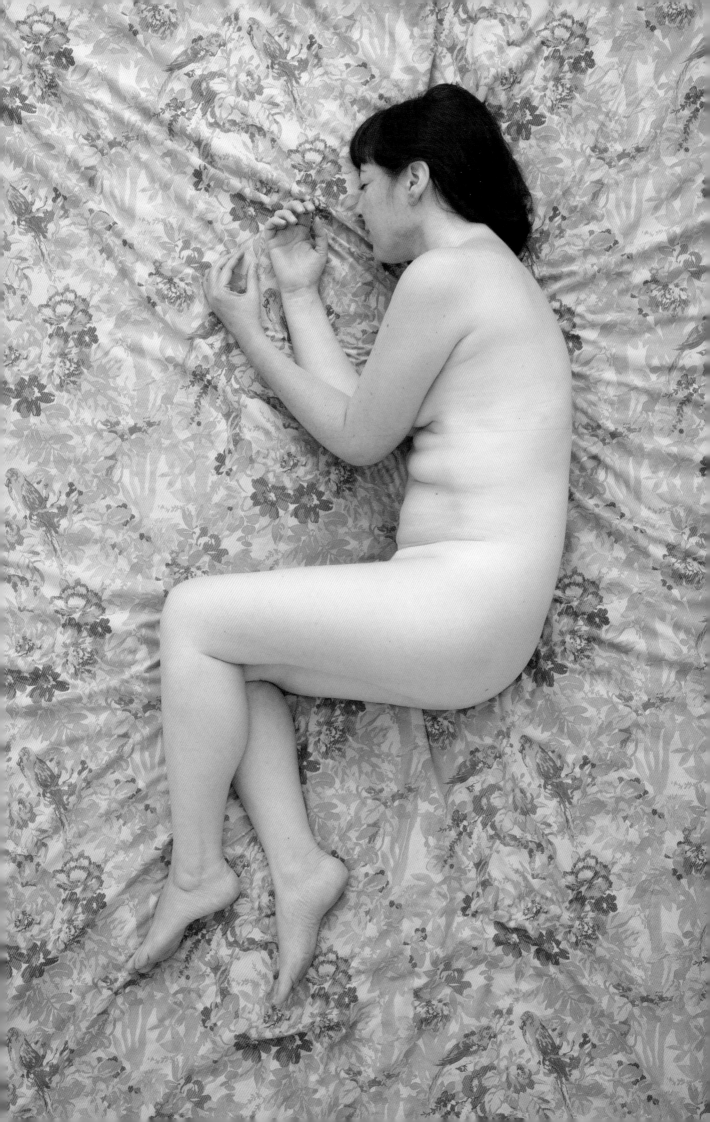

As a woman who is childless by circumstance, I have hidden my grief and shame as it's not something people talk about. My pain and sadness will always be part of me, but I'm hoping that by being in this book I can turn these emotions into something more positive.

Nicole

I've always questioned the assumption that motherhood is a foregone conclusion. Motherhood doesn't equal womanhood, yet this is still how we are conditioned to think. I'm forging my own path of fulfilment, and encourage other women to do the same, however that looks. We all contribute and create in unlimited ways.

Michelle

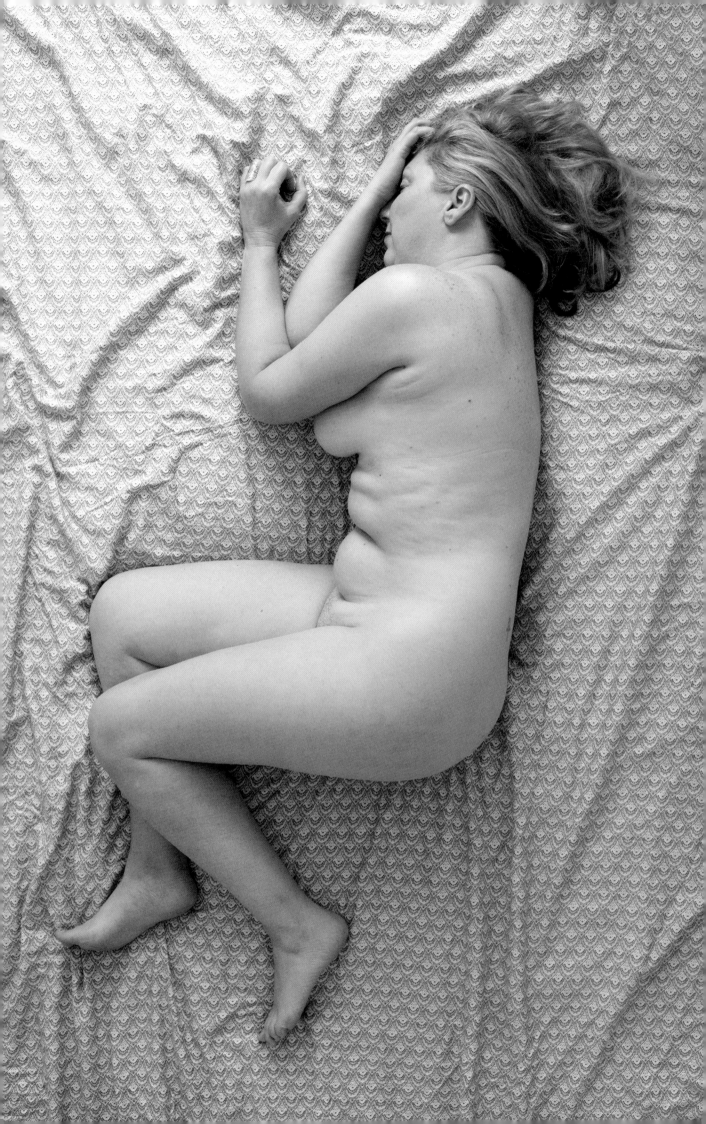

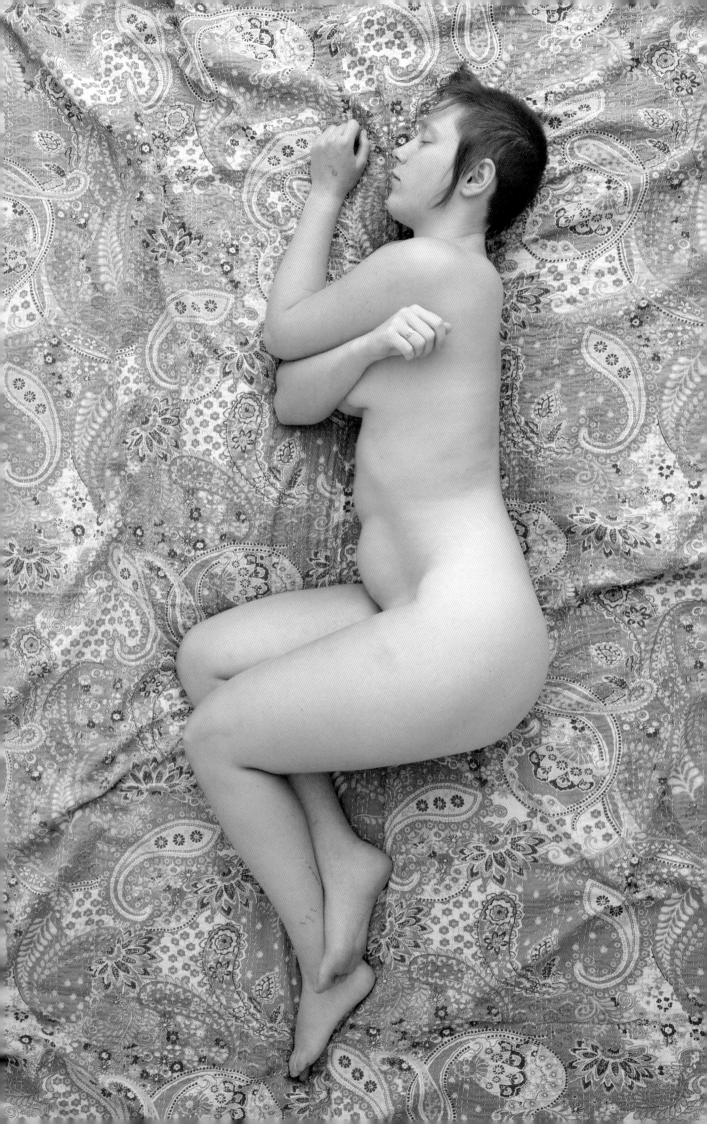

Having a child is an incredible adventure; just not my adventure.

Bibi

I never felt a deep burning desire to have kids; without this, motherhood to me just looked like a lifetime of stress and worry. So my choice was easy. In fact, I feel free.

Sarah

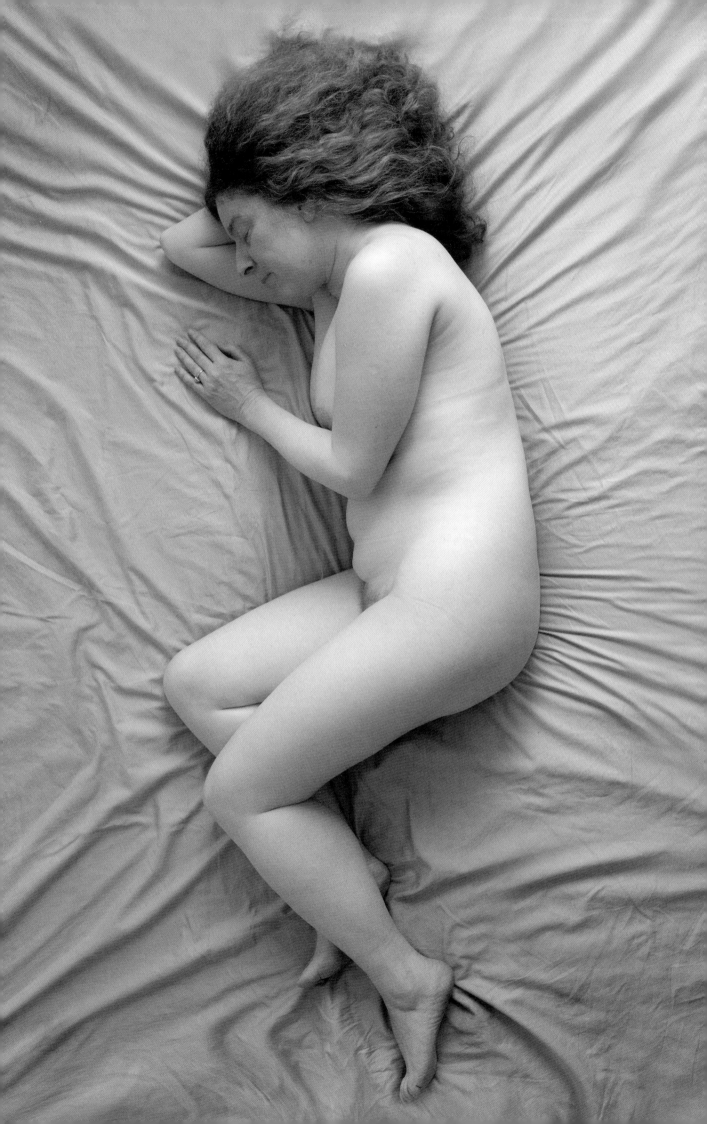

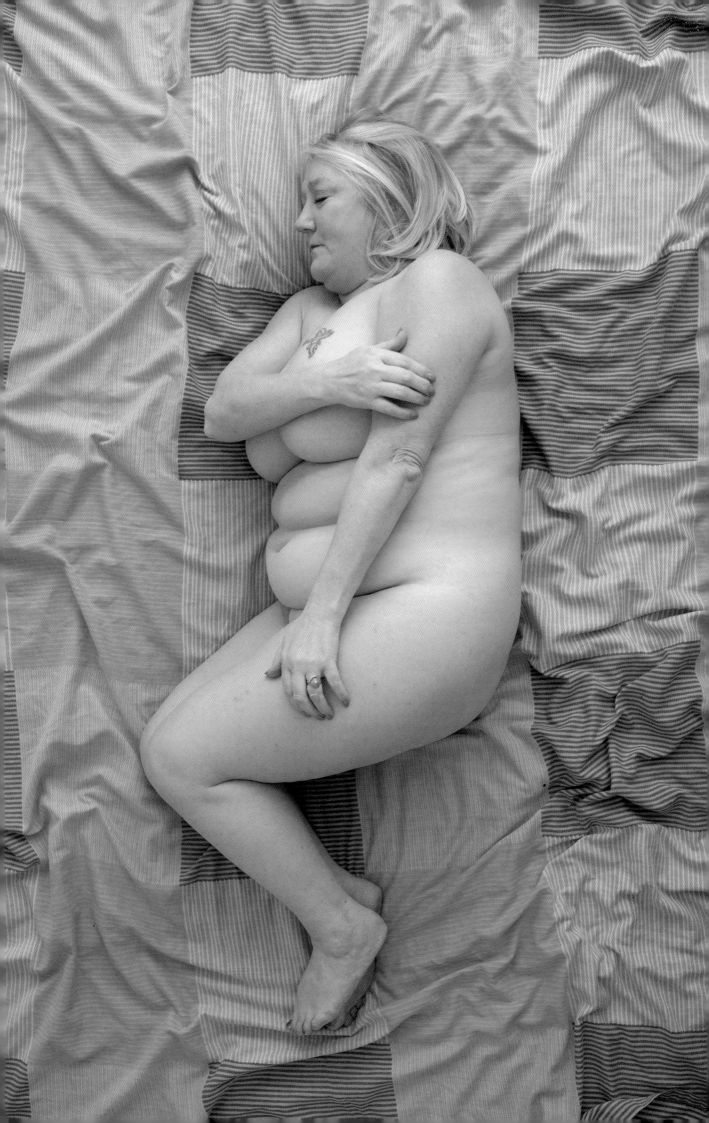

My husband and I never wanted to bring children into this terrible world we live in. Now I am 59 I regret my choice. I am so envious of all my family and friends who have these beautiful, funny, caring, quirky lickle human beings; most of my friends have grandchildren as well.

Tonia

We had to make the hard decision not to have children because I have serious issues with my back. Suddenly, I was living with a heavy black hole inside me. Dark and empty: I was grieving for somebody who wasn't even there. Our future completely shifted on its axis to an unconsidered outcome, while on the outside we just had to carry on as normal.

Emma

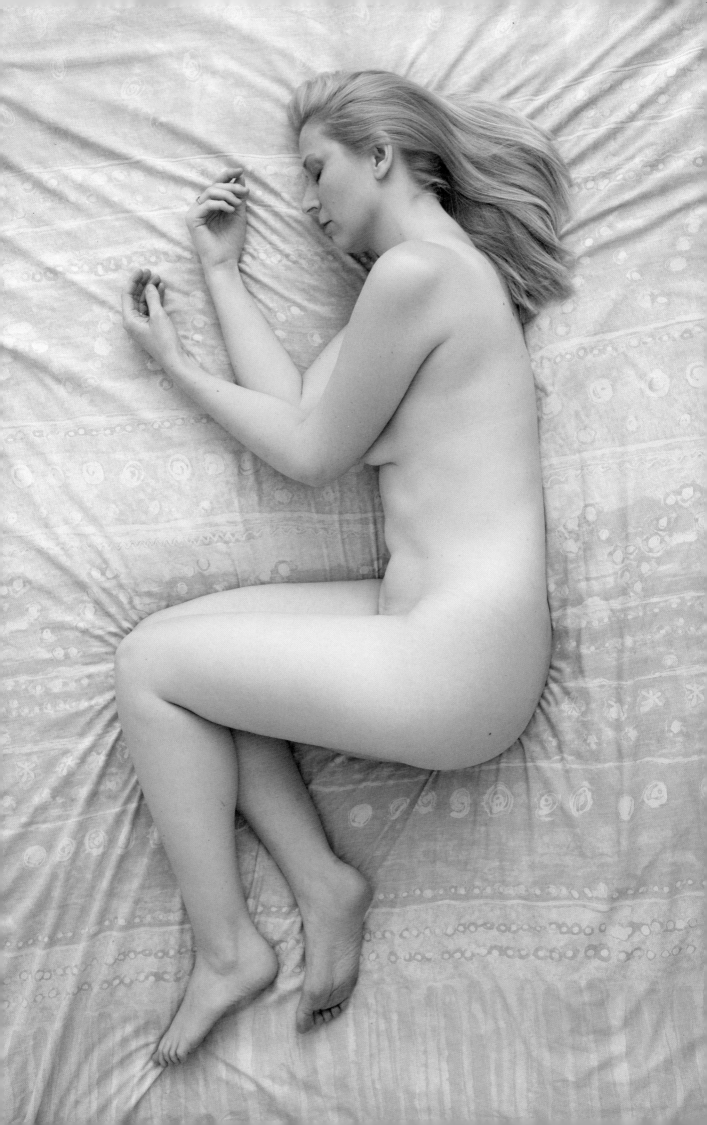

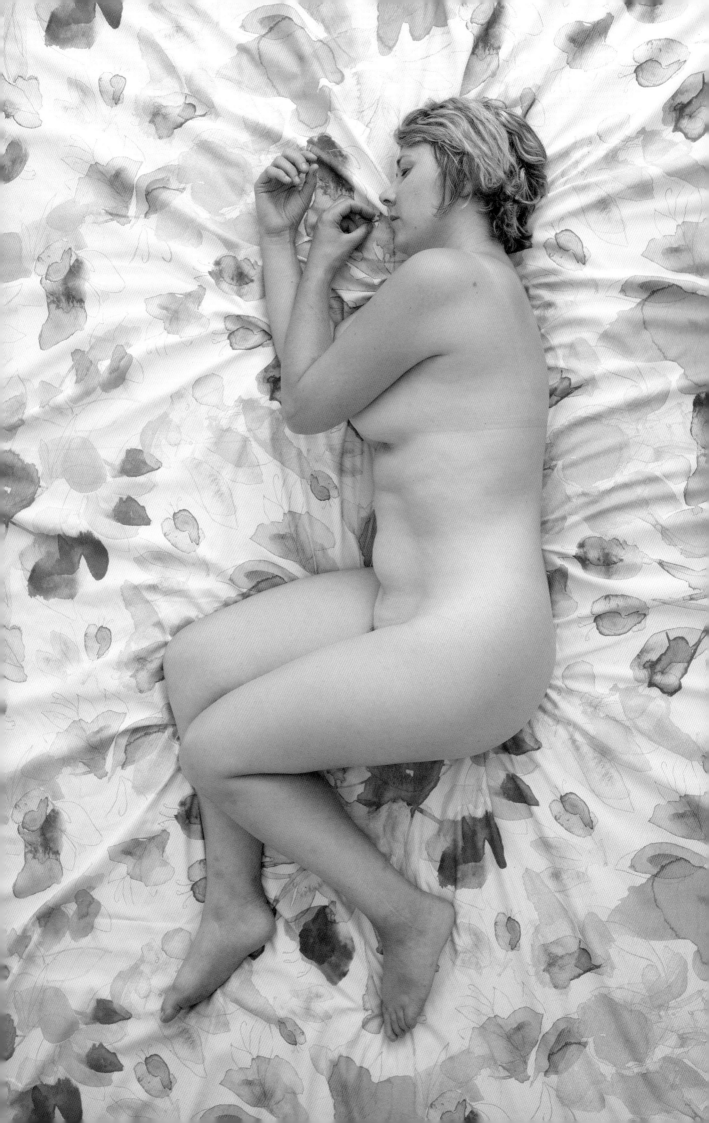

Probably a combination of being a free spirit and a bad choice of men is the reason why I don't have children!

In my teens I travelled extensively, and my experiences will stay with me forever. I studied art for films and theatre, and now run my own business. Looking back, I never had the time to have children. I always found I had something more important to do.

Nikki

There are so many reasons why I chose not to be a mother that it would be more like trying to find a reason to have a child.

Kit

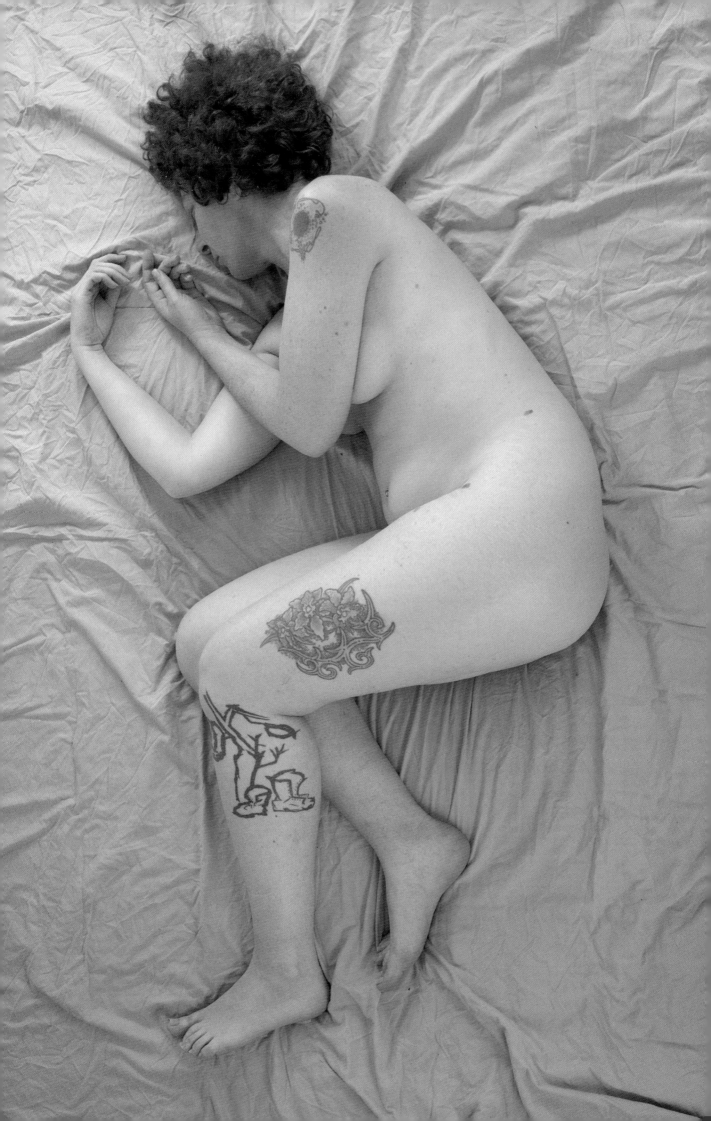

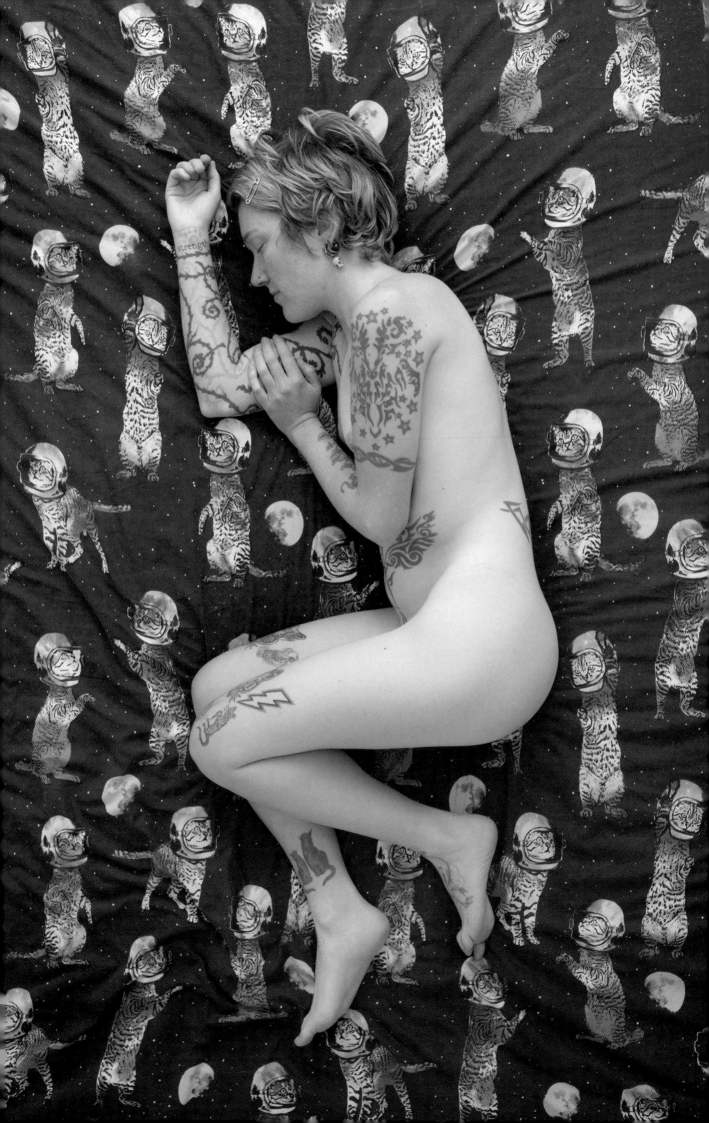

I've never wanted children; I don't think I'm particularly maternal. I love being an auntie to my little nephew, and enjoy time with him, but it's not given me the desire to have my own.

To be honest, human babies don't really interest me; I'm happy to have two wonderful cats.

Justine

I lost my son.

Stacey

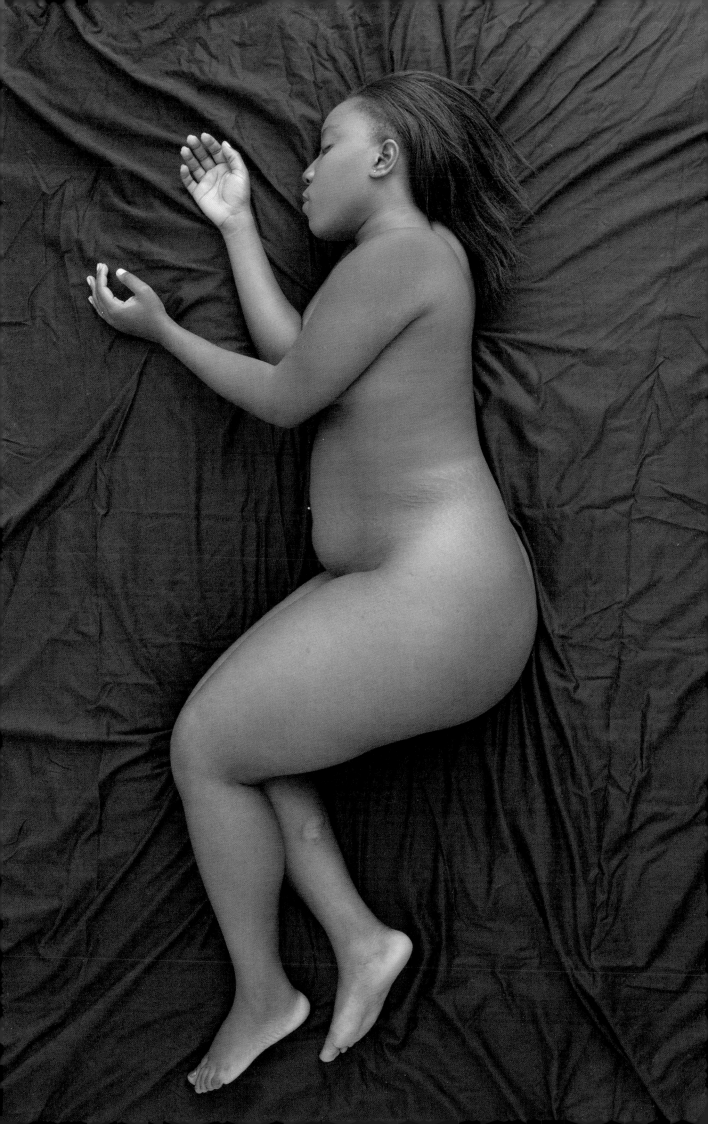

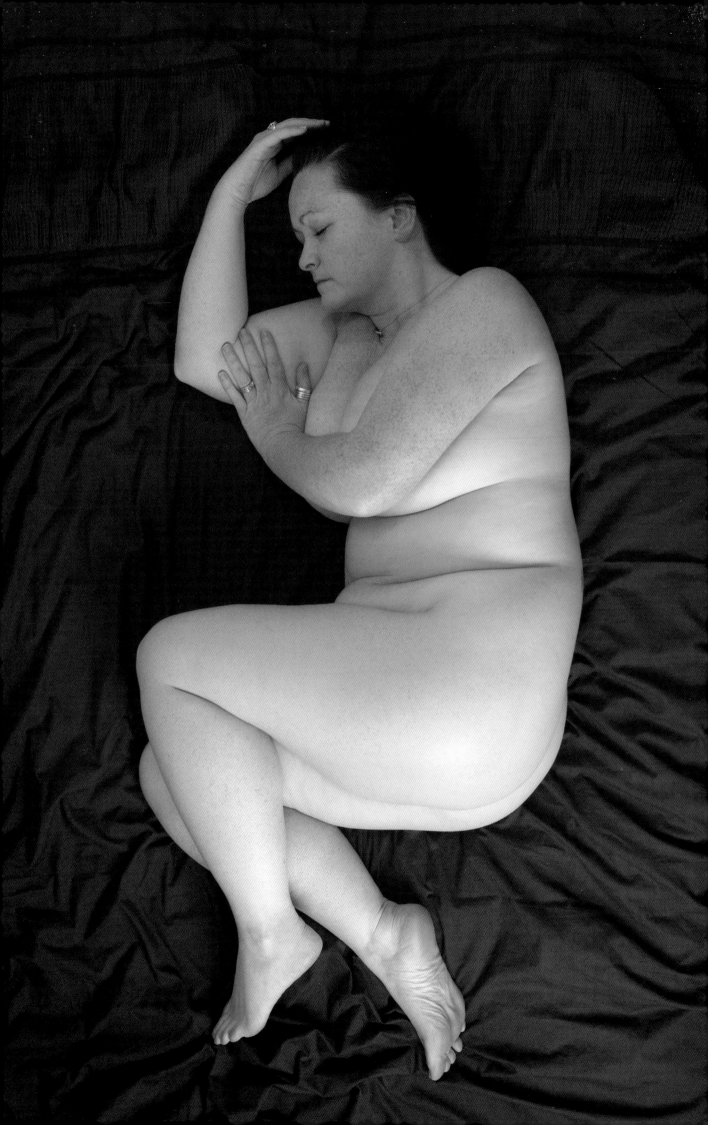

I am an aunt to many and mother to none. I have never felt the need, or that I have missed out.

Rebecca

I'm not maternal and I would have to compromise
myself as an artist-performer if I had kids. I realised
from a very young age that I have choices.

Lisa

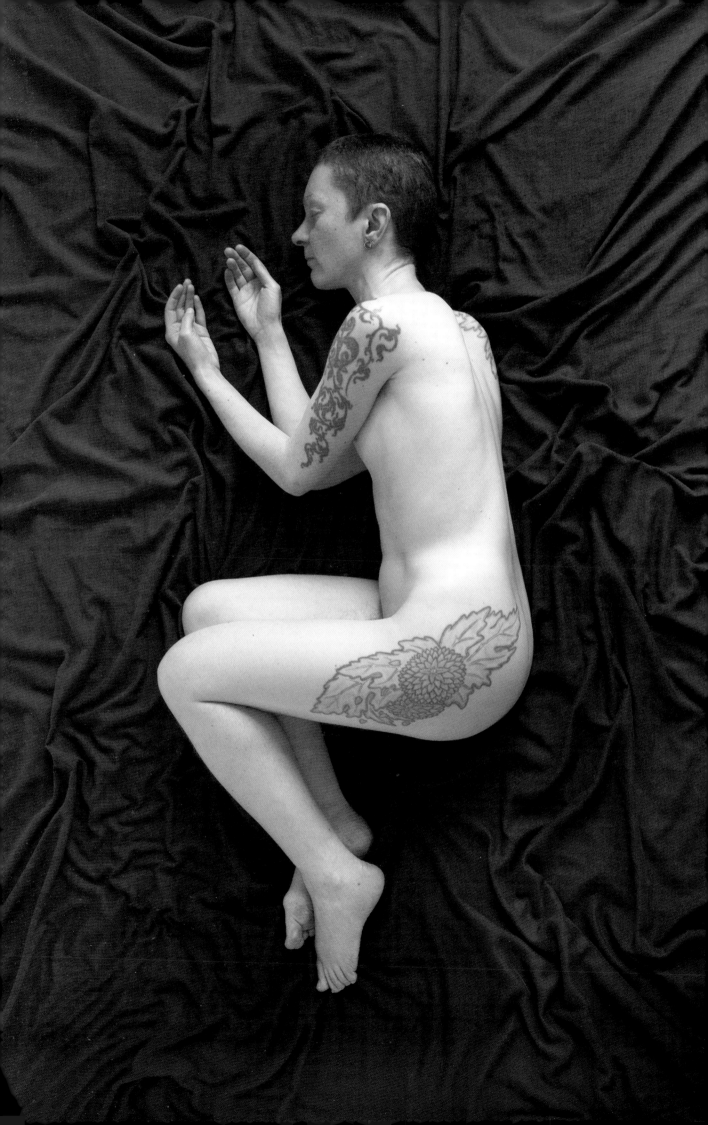

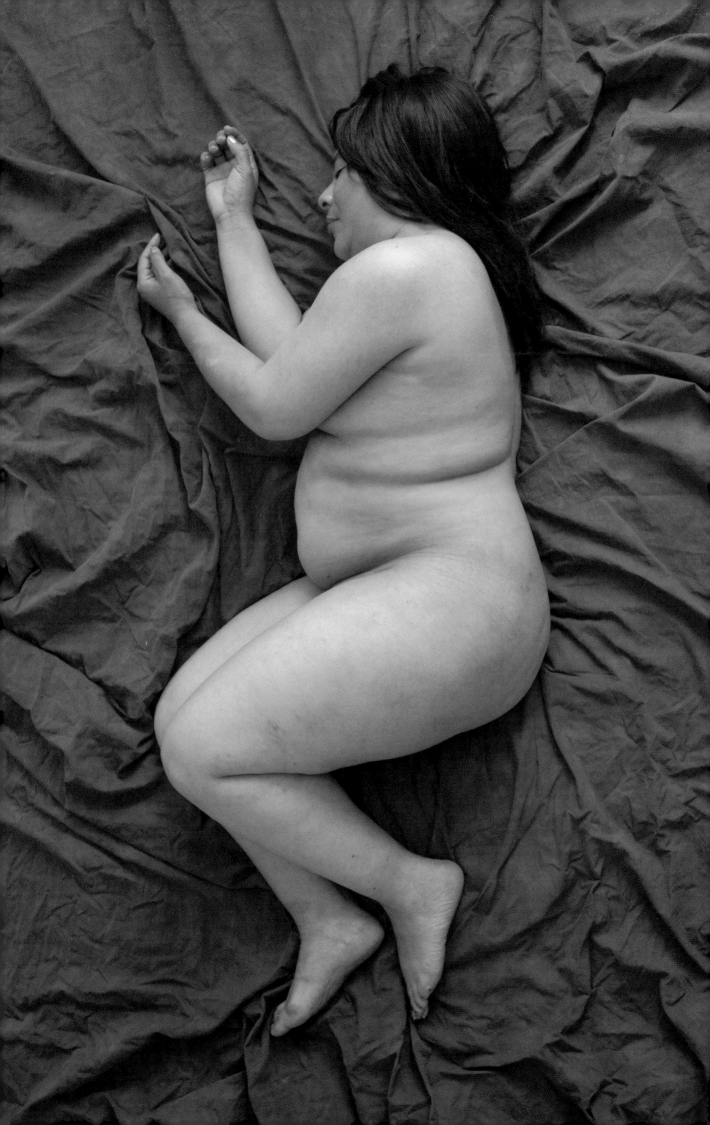

When I was 40, I was told by an unsympathetic male doctor that I was in early menopause, and couldn't have children.

Michelle

I recently made a decision to have an abortion. Hard as it was, I believe it was the right thing for that time in my life.

I pray I get the opportunity again to make a different choice.

Ria

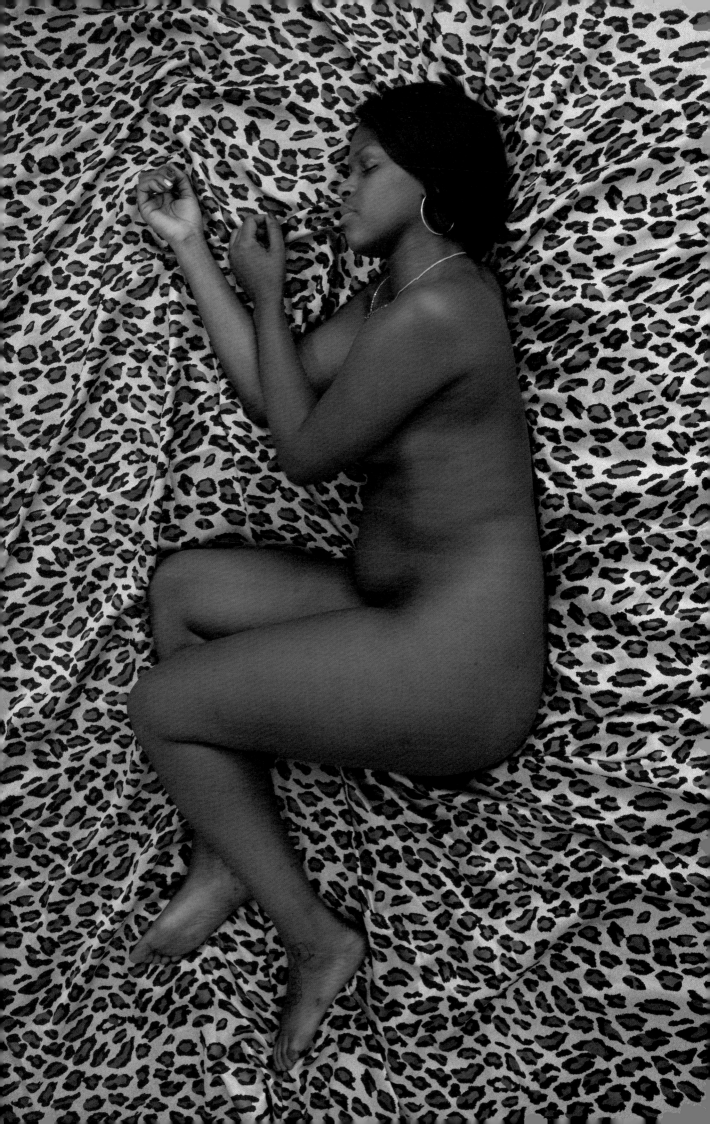

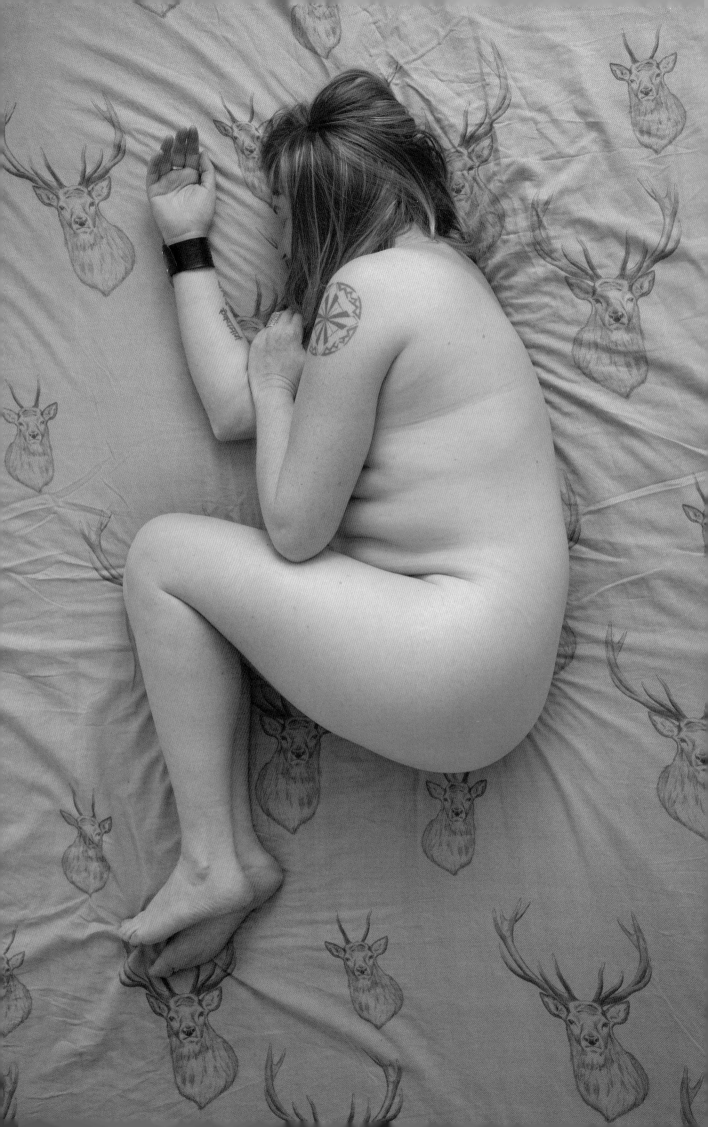

My mother, and many mothers I know, have not inspired me to have children. I'm deeply concerned I would become like my narcissistic mother.

Animals are preferable.

Anette

I always wanted to be a partner and a mum, to love and raise a family of my own, but it just didn't happen.

Instead of embracing motherhood, I'm learning (or not) to live with 'otherhood': deep grief, sadness, shame and uncertainty.

Naomi

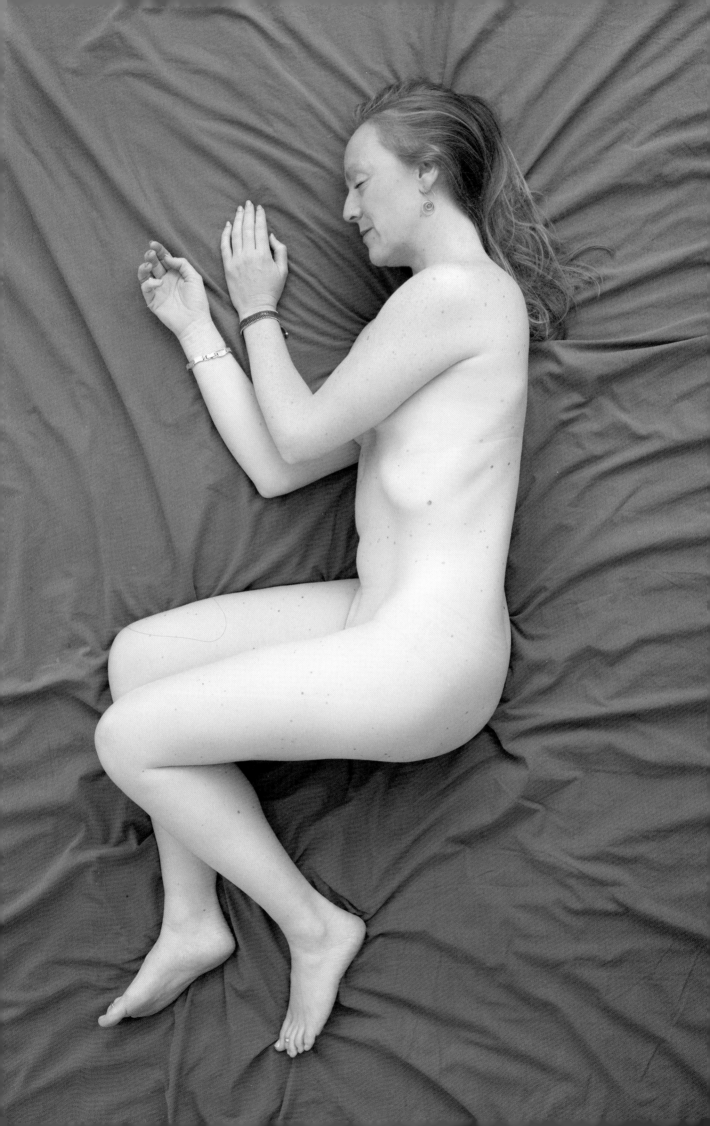

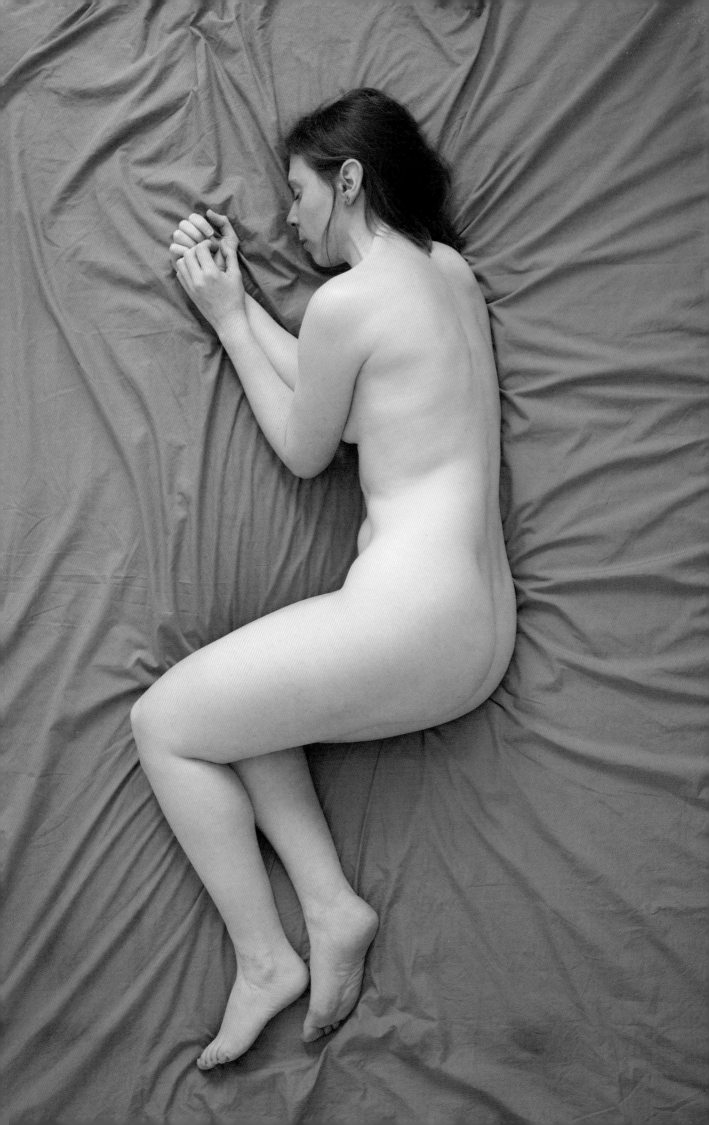

When I was a child I dreamed of being a volcanologist, not a mother. I never wanted to be pregnant; I've never been broody. I have never felt incomplete. I have so many more reasons why I wouldn't have a child than would.

With hindsight, I thank my parents for raising me without stereotyped expectations of what I would become.

Kat

I have known since I was about 18 that I don't want kids. Someone's newborn was being passed around, and it was obvious to me that I was not feeling the enthusiasm that the other girls were. Having kids always looked like a job to me – a job that I didn't want.

I feel lucky to be living at a time when I can choose to be childfree.

Amanda

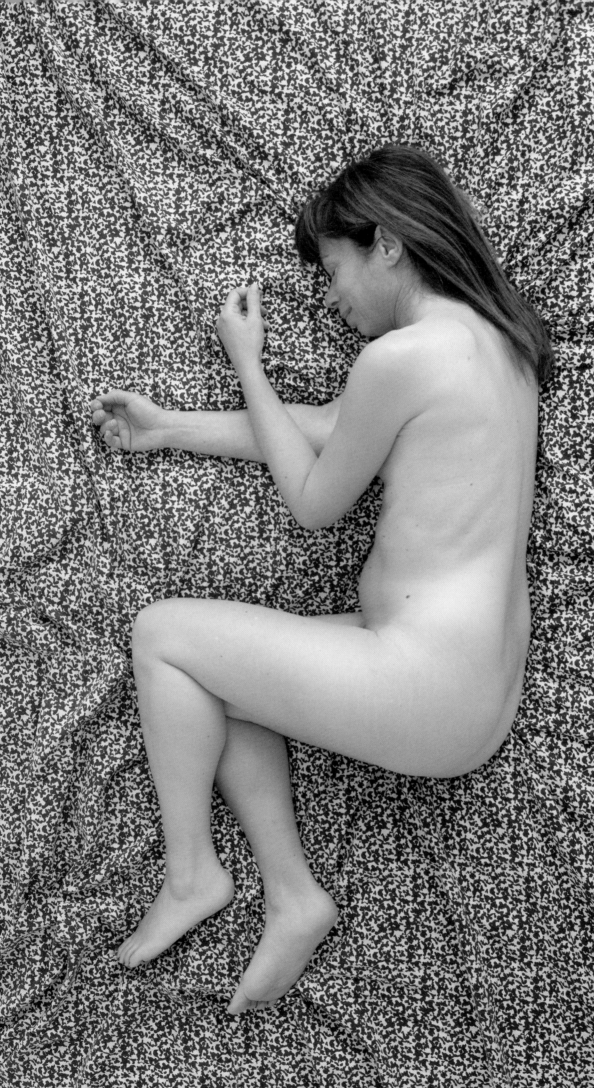

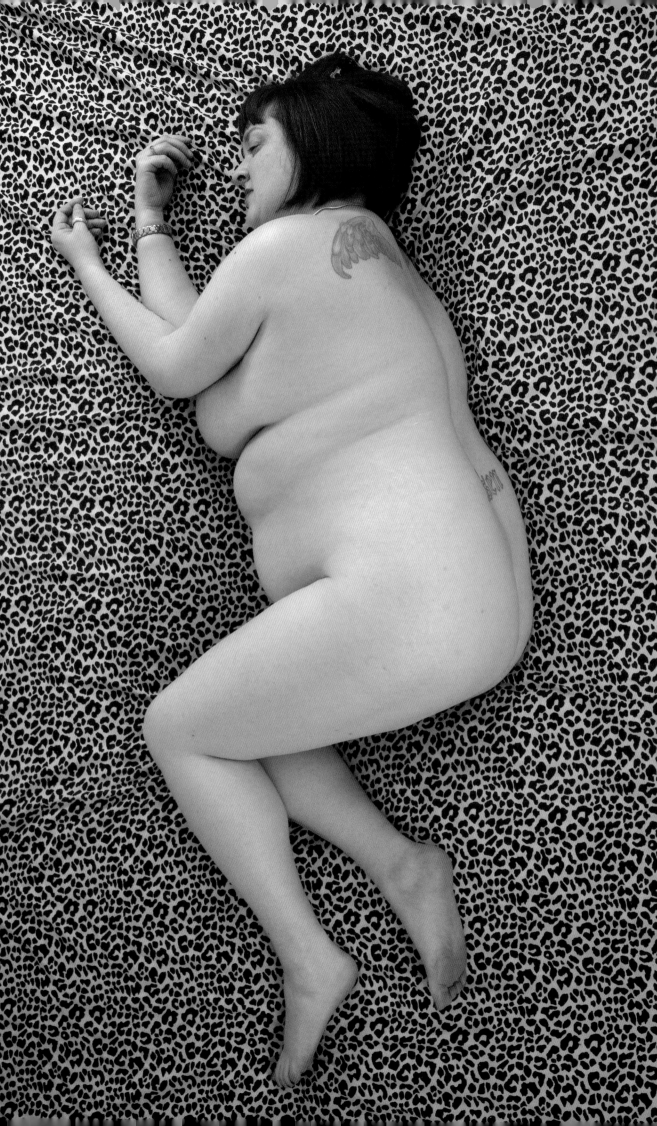

I prefer cats.

Lissa

It's hard to find the words to express what being childless means to me. It's the loss of the future that I wanted with my partner. The loss of love and laughter, and worry and sleepless nights. The loss of chaos and growing and hope. It's guilt and grief and pain and secret sobbing. It's a knife through my heart when I see other families.

Motherhood is not everything, it does not define women, but even so I find it almost unbearable to be childless.

Anna

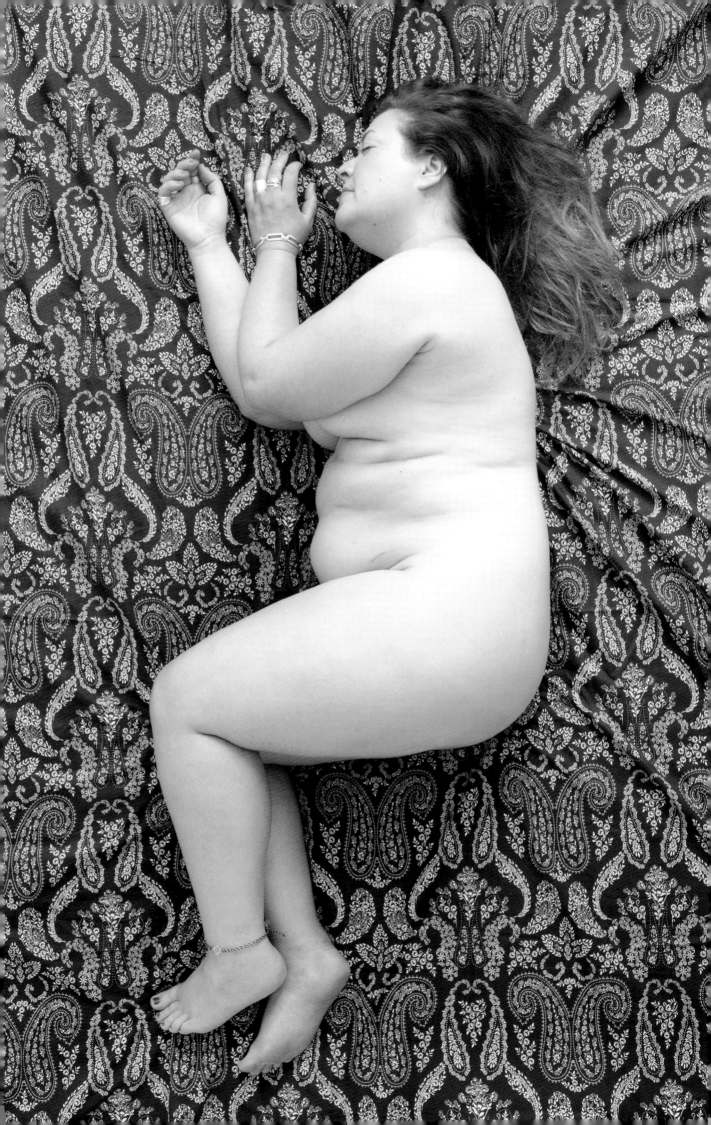

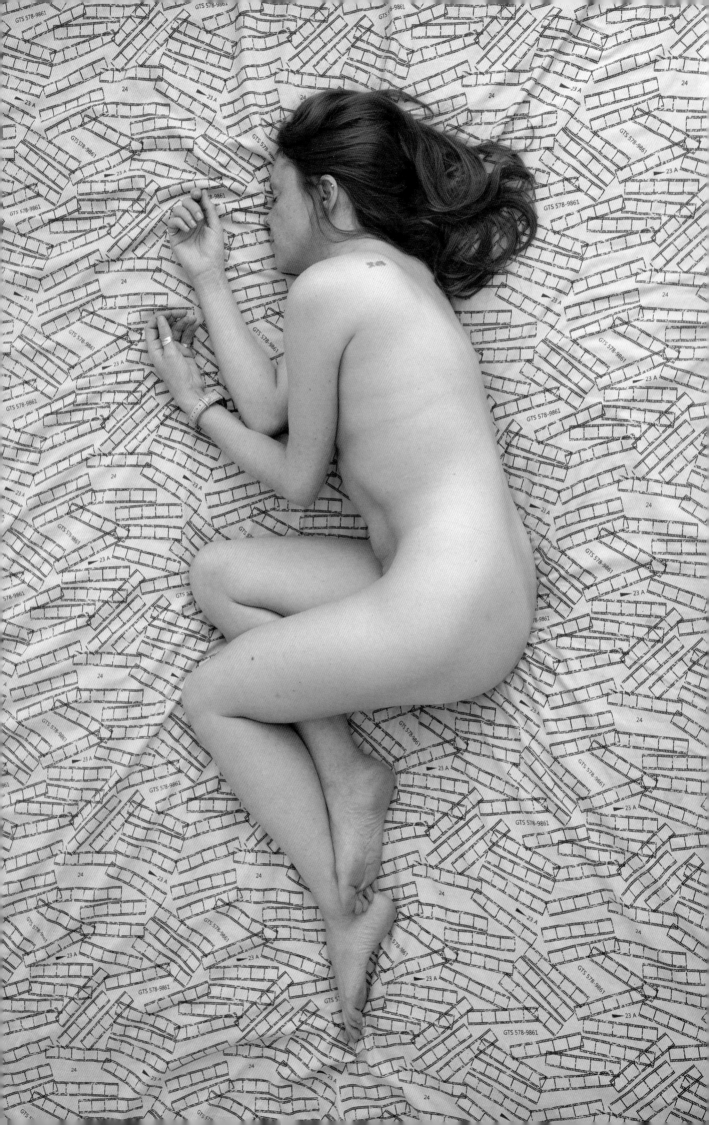

I never had a good relationship with my mother.

Ellen

A final word ...
The role of bias in
Mum's not the word

by Susan J Mumford

Denise Felkin embarked upon this project to "change attitudes and break down stereotypes about women who don't have children." What, then, is the reasoning behind such attitudes and stereotypes?

In 2014, I started what would become an ongoing programme of talks addressing equality and bias. This began in my capacity as Founder of the Association of Women Art Dealers (AWAD) at the Affordable Art Fair in London. That first keynote highlighted three notable women in the arts from the 20th century (artist and suffragette Sylvia Pankhurst, gallerist Lillian Browse, and artist Elisabeth 'Lis' Frink). I provided a comprehensive description of each figure, and then asked who was being described. The audience of fifty art professionals knew of one, who was the only figure in living memory: Elisabeth Frink.

This highlights the importance of creating legacy for women that will stand the test of time. It's a reminder that prominent women have been omitted from history books, which is an example of bias. The *Oxford Living Dictionary*[1] neatly sums up the meaning of bias: "It's an inclination or prejudice for or against one person or group, especially in a way considered to be unfair. Beliefs or demographics most often cause biases."

By December 2016, I was focusing on unconscious (aka implicit) bias, in which one is not aware of having prejudices or making decisions based on their own beliefs or demographics. This led to the facilitation of a panel discussion during Miami Art Week titled, 'Unconsious Bias and the Art World,' which was a turning point.

Art collector Steven Alan Bennett was a panelist, and told the story of how he and his wife, Dr Elaine Melotti Schmidt, came to focus on acquiring realist art of women, by women. When preparing to start The Bennett Collection, they engaged an art advisor. The portfolio was fully comprised of works by male artists. The (woman) advisor explained that investing in pieces by men is a safer bet, and their response was to focus solely on women.

Steven's story is an example of conscious bias at play. The more you dig into the subject, the more you acknowledge its presence, from professional to personal life, which brings us to *Mum's not the word*.

The outwardly negative responses to women who are childless and childfree are displays of bias. The very notion that a woman being without child is an unfortunate reality or a terrible decision results from beliefs, demographics of one's own community, and other circumstances that inform this view. Ask any individual depicted in these pages, and she'll be able to tell you how she's personally been impacted by others, whether or not they were aware of what they were doing or saying.

Only once you become aware of having bias, in which it enters the realm of consciousness, can you do something to change behaviour. After being deeply touched by the stories in *Mum's not the word*, you're encouraged to stay on the lookout for your reactions, as well as those of others, in the months and years to come, to identify and address your own biases. Everyone has them, and the first step to making change is recognition.

susanjmumford.com
@susanjmumford

[1] https://en.oxforddictionaries.com/definition/bias